EVERYTHING
YOU EVER WANTED TO KNOW ABOUT
CARTOONING
BUT WERE AFRAID TO DRAW

EVERYTHING
YOU EVER WANTED TO KNOW ABOUT
CARTOONING
BUT WERE AFRAID TO DRAW

CHRISTOPHER HART

WATSON-GUPTILL PUBLICATIONS/NEW YORK

For Isabella and Francesca

I'd like to thank

MARIA HART for her patience,
comments, and pesto sauce;

CRAIG BRAUN, for sharing
his expertise;

and also my friend,
JACK HANDEY (because he
thanked me in his book).

Christopher Hart is also the author and artist of the books, *How to Draw Cartoons for Comic Strips, Making Funny Faces—Cartooning for Kids and Grown Ups, How to Draw Cartoon Animals, How to Draw Comic Book Heroes and Villains, Christopher Hart's Portable Cartoon Studio* and *Christopher Hart's Portable Animation Studio,* all published by Watson-Guptill Publications. Hart started working in cartooning at an early age, designing characters for animated commercials at the age of seventeen. He studied at the California Institute of the Arts, then went on to earn a Bachelor of Arts degree from New York University.

He is a regular contributor to *Mad* magazine, has worked on the staff of the world-famous comic strip, *Blondie,* and has been a contributor to *Highlights Magazine for Children.*

Hart is also a writer and director of films and television. He co-wrote and directed the feature film, *Eat and Run* (New World Pictures), and has written movies for 20th Century Fox, MGM, Paramount Pictures and Showtime cable television network.

He teaches at the School of Visual Arts in New York City, and resides in Westport, Connecticut, with his wife and two daughters.

Senior Editor: Candace Raney
Associate Editor: Selma Friedman
Designer: Bob Fillie, Graphiti Graphics
Production Manager: Hector Campbell

First published in 1994 by Watson-Guptill Publications, a division of BPI Communications, Inc., 1515 Broadway, New York, NY 10036.

Library of Congress Cataloging-in-Publication Data

Hart, Christopher
 Everything you ever wanted to know about cartooning but were afraid to draw / Christopher Hart.
 p. cm.
 Includes index.
 ISBN 0-8230-2359-1 : $16.95
 1. Cartooning—Technique. I. Title.
 NC1320.H345 1994 93-39038
 741.5—dc20 CIP

Distributed in the United Kingdom by Phaidon Press, Ltd., 140 Kensington Church Street, London W8 4BN, England.

Distributed in Europe (except the United Kingdom), South and Central America, the Caribbean, the Far East, the Southeast, and Central Asia by Rotovision S.A., Route Suisse 9, CH-1295 Mies, Switzerland.

Manufactured in China

First printing, 1994

9 /02 01 00

CONTENTS

INTRODUCTION

Congratulations! By selecting this book you have made a wise choice, because within these pages lie the secrets of character design, special effects, layout, and LIFE ITSELF! ...Okay, I went over the top with that one. But there's good stuff in here, and this is why...

This book will guide you step-by-step through the basics of how to draw the head and figure, and much more. If you want to know how to draw animals, it's in here. If you'd like to learn how to draw cave men, knights, and fire-breathing dragons, it's in here. Wondering how to draw backgrounds without struggling with perspective? That's in here, too. Weather effects, explosions, dizzy stars—everything you've ever wanted to know about cartooning is in this book.

This book reveals secrets of cartooning heretofore known only to the professional cartoonist— techniques such as creating speed lines and cartoon sound effects, and how to choose the right colors for your creations. These are techniques that do not appear anywhere else. They are all broken down in easy-to-understand language.

I am sharing with you, in one book, what took me years to learn.

If a book like this had been around when I got started, it would have saved me much time. Therefore, it is my sincere desire that this book will be like a friend at your side, a friend who doesn't stay too long or come for a visit with his suitcase. I have such friends and, believe me, this book is better.

Anyone can learn to draw a face. But is that all you really want to do? Of course not. This book will show you how to invent your own characters and how to create humorous situations for them. In short, this book will show you not only how to draw, but what you can do with your drawings once you have drawn them.

I'll start at the beginning, then ease into intermediate techniques, and then progress to more advanced cartooning. You will not have to go out next week and buy another book because you've outgrown this one. This book grows with you. It is also an excellent source for cartoonists, animators and illustrators.

We cartoonists have some things in common. We love pencils, we hate punching time clocks, and we'll never grow up. If you're one of us, why are you still reading? Sharpen that pencil, and let's get going!

BREEZING THROUGH THE BASICS: HEAD CONSTRUCTION

The head is incredibly versatile. It can be stretched or squashed. The facial features can be drawn realistically or exaggerated wildly.

And yet, the basic construction of any cartoon head, whether subdued or extreme, must be rock solid. Most people can happen upon a good drawing while doodling. But few people can reproduce that drawing in varying poses so that it retains its recognizability. That is because the basic construction was not in place or was not understood.

Learning the principles of head construction is what separates the cartoonist from the doodler. It is the essence of cartooning.

Building a head is like building a house, except that you don't need hammers or liability insurance. Start with the foundation and work toward the details.

We separate the head into two parts: a circle and a jaw. You will notice that the axis lines in the circle are used as a guide on which to hang the features.

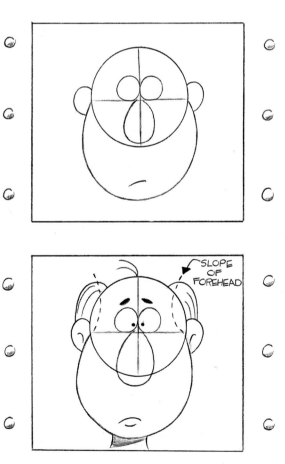

SLOPE
OF
FOREHEAD

The Nose

The nose is the "arrow" of the face. No matter which way the eyes are looking, the face always points in the direction of the nose. The nose is also the central focus of the face. Therefore, when drawing the features, I always begin with the nose.

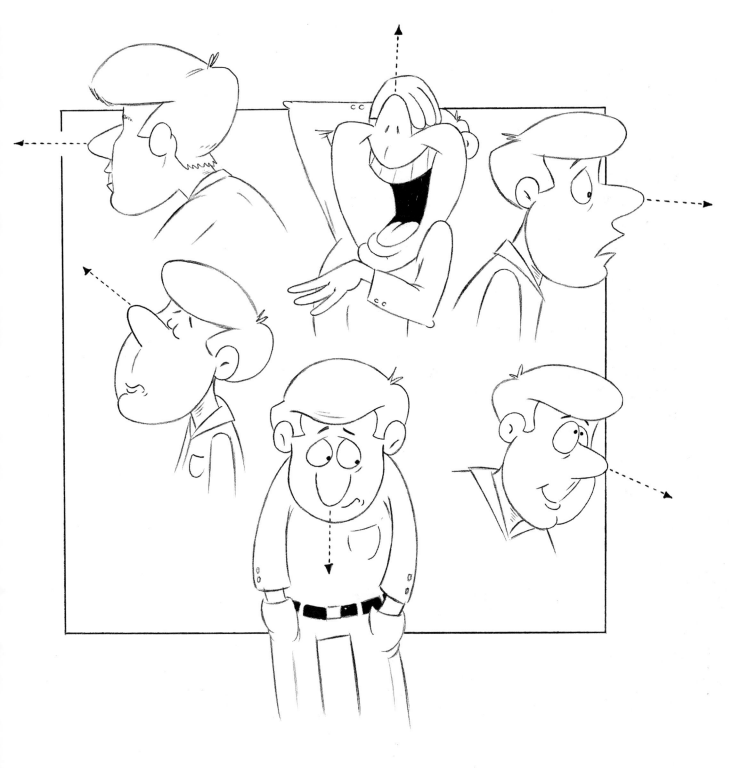

Placing the Features

Think of the head as a globe. As we rotate the globe, the placement of the features remains constant.

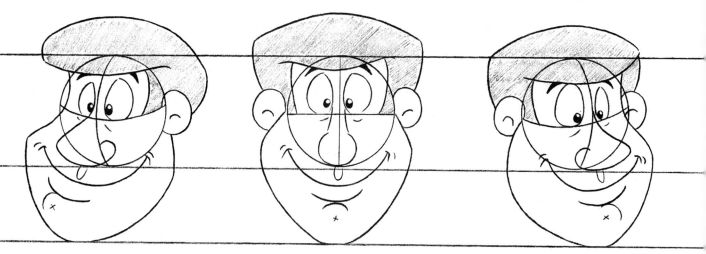

3/4 VIEW—LEFT FRONT VIEW 3/4 VIEW—RIGHT

The standard 3/4 view shows only one ear. The other remains hidden.

This variation shows two ears, creating a fuller looking face. Both are correct.

Varying the Placement of the Features

You can raise or lower your character's eye-line, which is the horizontal line on which the eyes are placed. But once you have decided where it is to go, you have to keep it there for the life of that particular character.

This perky lady has the lowest eye-line possible—her eyes are resting at the bottom of the circle itself. Young or characters always have low eye-lines, giving them large foreheads on which big eyes can be drawn.

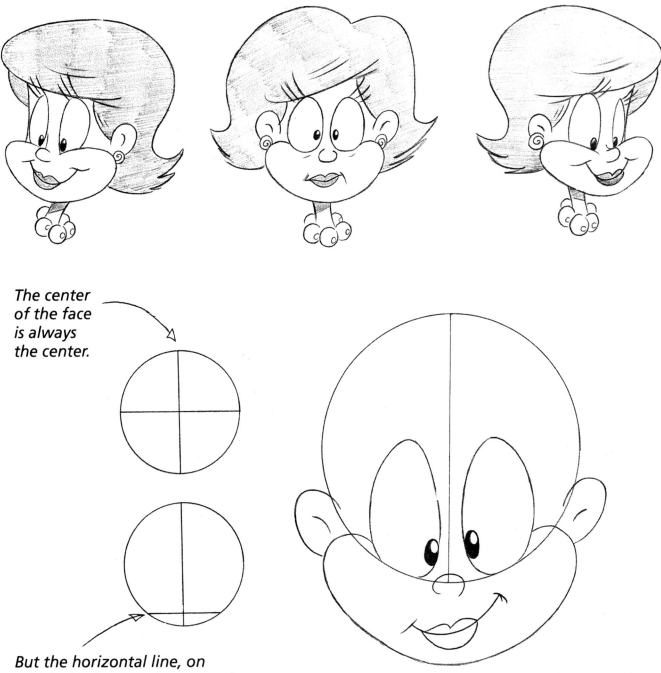

The center of the face is always the center.

But the horizontal line, on which the features hang, can be raised or lowered, resulting in varied character construction.

Solid Geometry

You've drawn a circle for the top of the head. This time, try using an oval. Try narrowing or lengthening the size of the jaw.

Sometimes a character's jawline is clearly defined, as is the case with the princess character. Other times, the jaw is buried in a sloping neck, as is the case with the man. If you first make modifications in the basic head construction, the details just seem to fall into place.

The one thing that all of these different characters have in common is a solid construction that allows all the components to fit together snugly.

TRY THESE ON FOR SIZE...

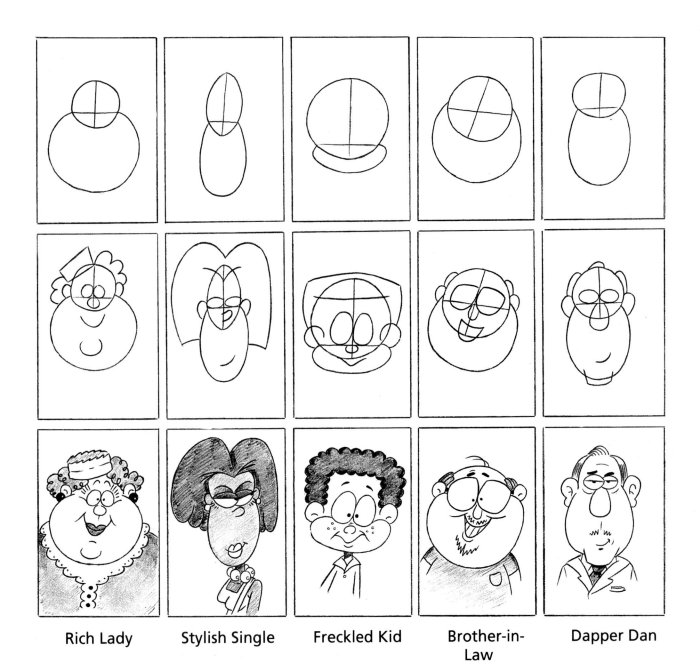

Rich Lady

Stylish Single

Freckled Kid

Brother-in-Law

Dapper Dan

Hair Styles, Hats, Mustaches, and Beards

Hair styles, hats, mustaches, and beards go a long way in defining a character. Put a man in a cowboy hat, and you can easily tell which part of the country he is from, perhaps even his vocation.

DRAW!

Always draw the basic construction first. Then add the hair style and the rest. Remember this, and you'll avoid a lot of errors, and save a bundle on erasers. Practice working with this sheriff character.

These different poses illustrate how the
hairline follows the contour of the head and
flows easily into the sideburns and the beard.

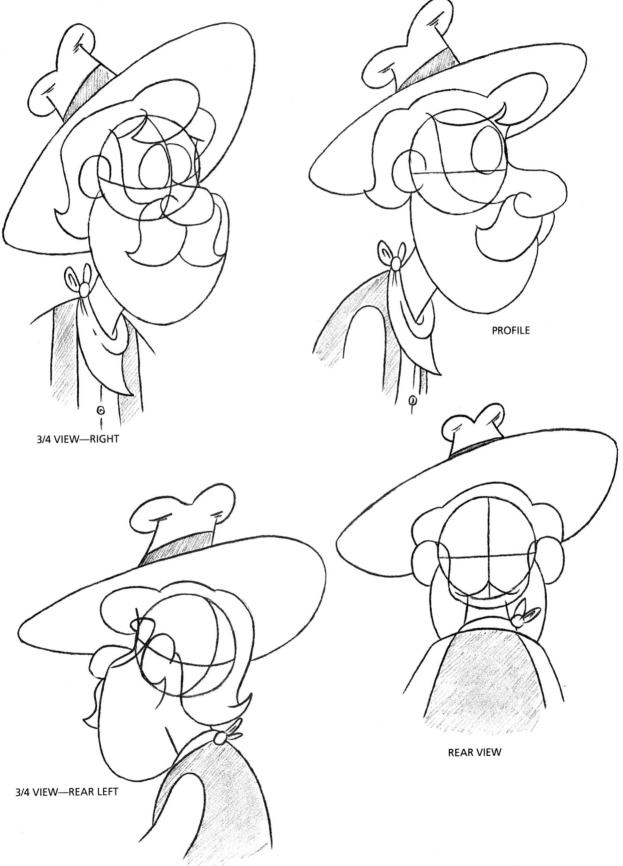

3/4 VIEW—RIGHT

PROFILE

3/4 VIEW—REAR LEFT

REAR VIEW

Drawing From a Cylinder

A stylized alternative to the circle-jaw construction is the cylinder. The cylinder can be rotated just like a globe or circle. This is a step further away from an anatomically correct head construction. Allow yourself the freedom to experiment.

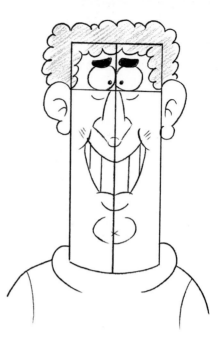

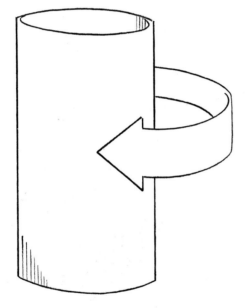

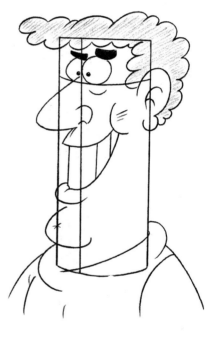

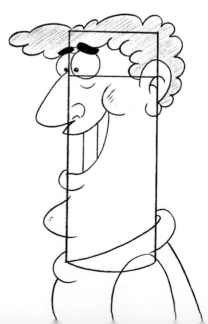

MORE CYLINDERS

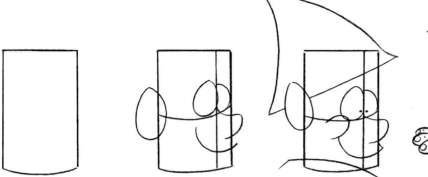

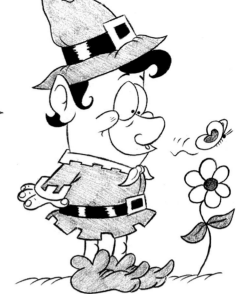

Heads drawn from a cylinder are not necessarily narrow. The cylinder can be widened, shortened, lengthened, or stretched.

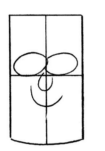

Taper off the forehead and soften the jaw, so that the drawing does not appear to be a hard rectangle.

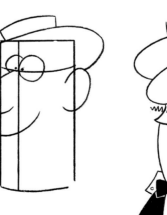
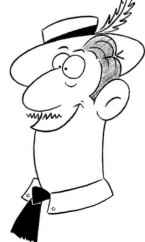

Expressions

There's hardly anything more enjoyable for the cartoonist than creating expressions for his characters. Use this chart as your reference guide.

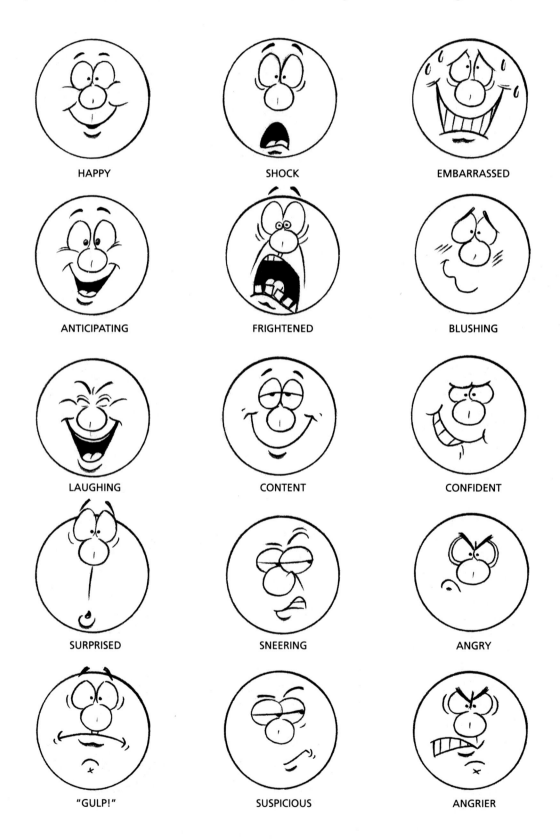

HAPPY

SHOCK

EMBARRASSED

ANTICIPATING

FRIGHTENED

BLUSHING

LAUGHING

CONTENT

CONFIDENT

SURPRISED

SNEERING

ANGRY

"GULP!"

SUSPICIOUS

ANGRIER

STUDY THE MIRROR

Professional animators often attach mirrors to their desks and use them to study their own facial expressions. Try looking into a mirror and making various expressions, but first be sure no one is watching. Now try to copy what you see. Don't concern yourself with the shape of the head. Expressions are created solely with the eyes and mouth.

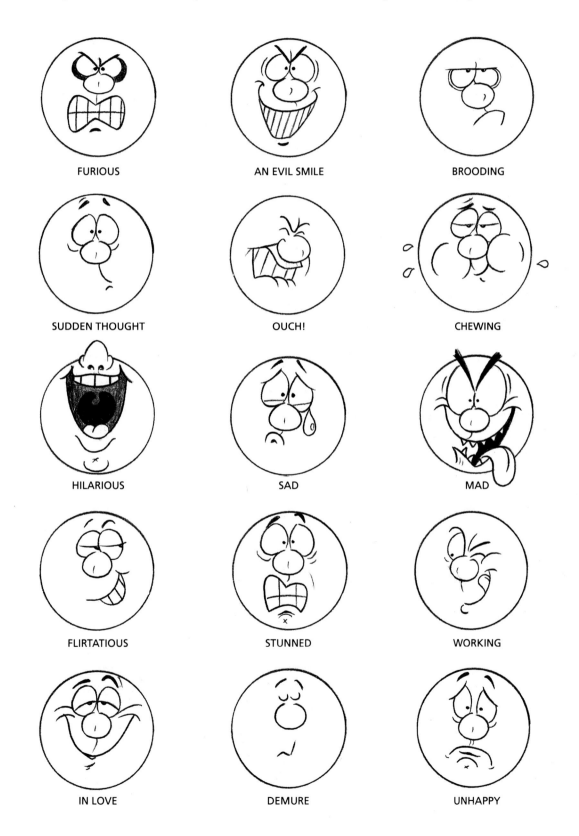

FURIOUS

AN EVIL SMILE

BROODING

SUDDEN THOUGHT

OUCH!

CHEWING

HILARIOUS

SAD

MAD

FLIRTATIOUS

STUNNED

WORKING

IN LOVE

DEMURE

UNHAPPY

BODY CONSTRUCTION

Bodies are easier to draw than you might think. Consider what you can tackle right now without any instruction. Can you draw an arm? Sure, that's easy, it's just two parallel lines. What about a leg? More of the same, only thicker and longer. (You can also think of arms and legs as pipes that curve and bend).

Yet when you ask a beginner to draw a body, you see a sudden look of fear flash across his or her eyes. Relax. We're going to make it simple and fun.

Broken down into its basic elements, the body is easier to draw than the face, because there are no interior features with which to concern yourself.

Since you can already draw arms and legs, the difficulty must lie with the torso. The torso is only one third of the entire body, which is broken down into three parts: torso, arms, and legs. The torso is the stretch of body running from the hips to the collar bone. Two arms hang from the torso. And the torso plops down unceremoniously onto two legs.

In the same way that you draw the construction of the head *before* you draw the features, you should draw the torso before you draw the arms and legs.

Four Basic Body Constructions

Cartoon anatomy borrows from correct anatomy, but is more concerned with conveying one shape that instantly catches the eye. Therefore, keep the torso visually simple. Different cartoonists favor different constructions. By practicing you will discover your favorite. Experiment.

These body constructions can be adapted to fit women by making three slight adjustments: narrowing the waist, widening the hips, and adding breasts.

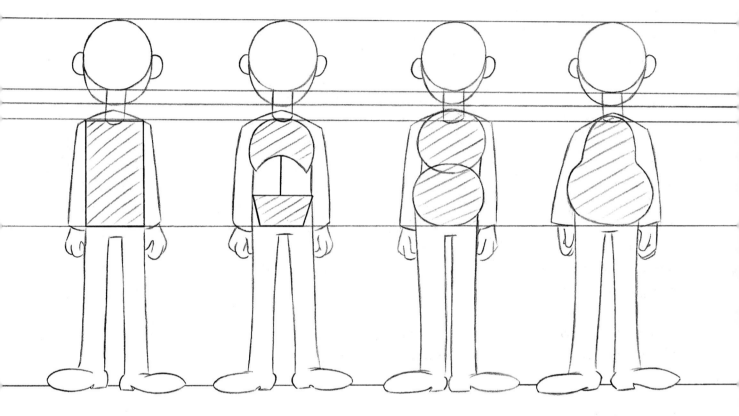

RECTANGLE
For average, skinny, and tall builds. This is an easy, effective, and very versatile construction.

RIB CAGE AND PELVIS
For athletic builds. This construction gives you freedom to expand the chest to any size, independent of the hips. It is also excellent for action poses in which the body is twisting or bending.

CIRCLES
For fat, cute, and mildly plump builds. The figure can be adjusted to create a bully's or an athlete's build by increasing the size of the upper circle. This is also an easy and effective construction, but it tends to be old fashioned.

PEAR
For average, cute, fat, young, old, or wise-guy builds. This is a versatile and very popular construction, and it is also an easy one. It's a standard.

The Classic Cartoon Woman

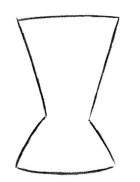

Draw an hourglass.

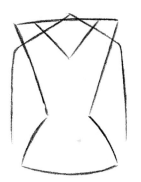

Indicate the "V" neckline and taper the shoulders (trapezius muscle), which connect to the arms.

Add the neck, indicate the collar bone, and add the breasts.

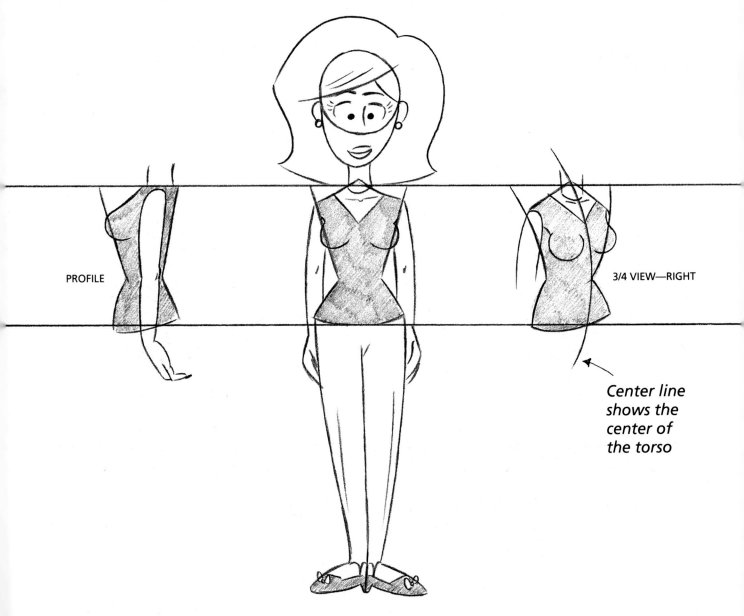

PROFILE

3/4 VIEW—RIGHT

Center line shows the center of the torso

Leg Spacing—Women

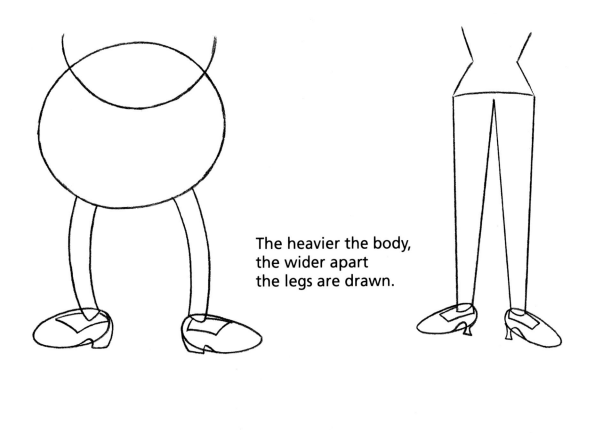

The heavier the body, the wider apart the legs are drawn.

Leg Spacing—Men

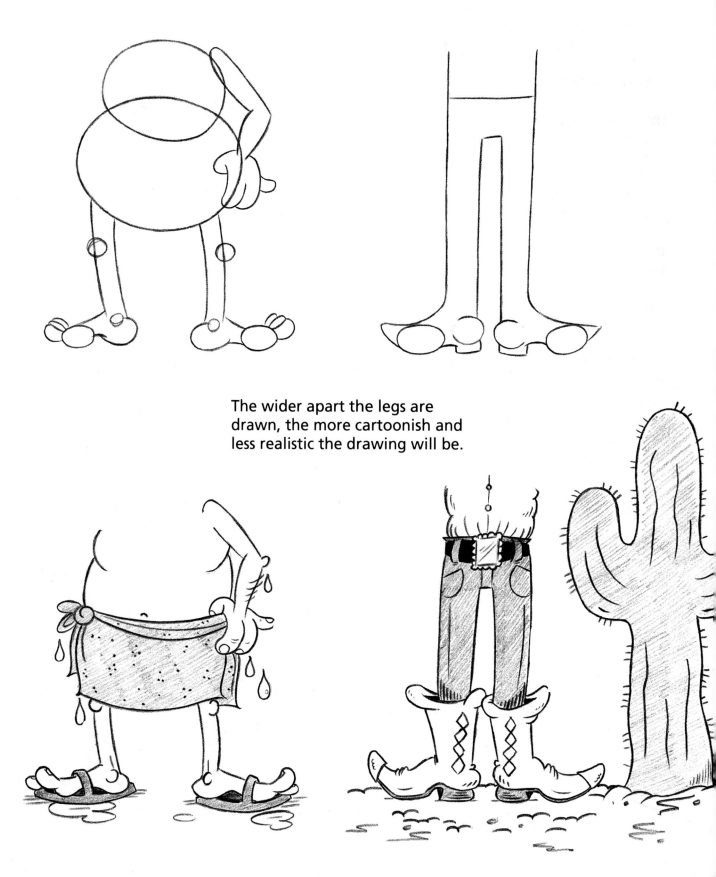

The wider apart the legs are drawn, the more cartoonish and less realistic the drawing will be.

Shoulder and Hip Dynamics

When you rest your weight on one foot, without your being aware of it a host of dynamics are suddenly set into motion.

The supporting leg (the one with the most weight on it) pushes that hip upward. To compensate, the shoulder on the same side slopes downward, putting a crease in that side of the torso.

The opposite side of the body is just as busy. The leg at rest pulls the hip downward. To compensate, the shoulder on that side lifts up.

These poses have visual tension, which makes them appealing. Shoulder and hip dynamics work just as well in extreme or subdued poses. Without shoulder and hip dynamics, we would all be standing at attention all of the time.

Any time a pose pushes one shoulder higher than the other, the body must react by following these guidelines.

SUPPORTING LEG
Leg is locked, pushing torso upward. Shoulder dips to compensate.

LEG AT REST
Leg is bent or relaxed, pulling hip down, causing torso to stretch, Shoulder rises to compensate.

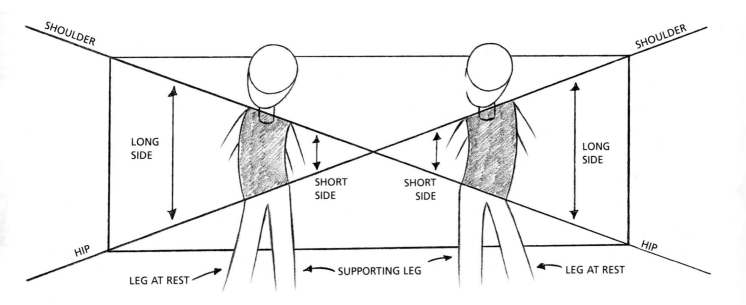

Action Line and Motion Line

Think of the Action Line as an extension of the spine. It's an invisible line that indicates the general direction toward which the body is leaning. By sketching the Action Line first, and then building the body onto it, you give your poses more fluidity, emphasis, and ease.

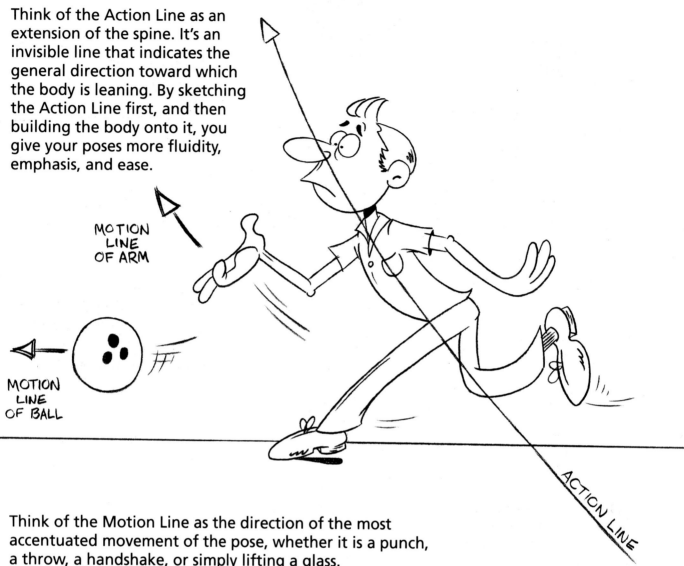

MOTION LINE OF ARM

MOTION LINE OF BALL

ACTION LINE

Think of the Motion Line as the direction of the most accentuated movement of the pose, whether it is a punch, a throw, a handshake, or simply lifting a glass.

The Motion Line and the Action Line are not necessarily linked in all poses. However, the greatest emphasis is achieved when the Action Line and the Motion Line point in the same direction. This will always result in an extreme pose, and can often be quite humorous.

Note how the facial expression changes to reflect the greater intensity. Even the ball warps from the increased velocity.

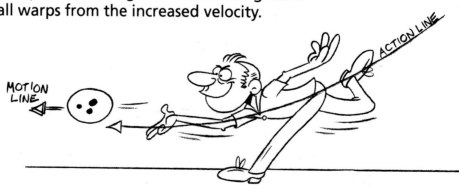

MOTION LINE

ACTION LINE

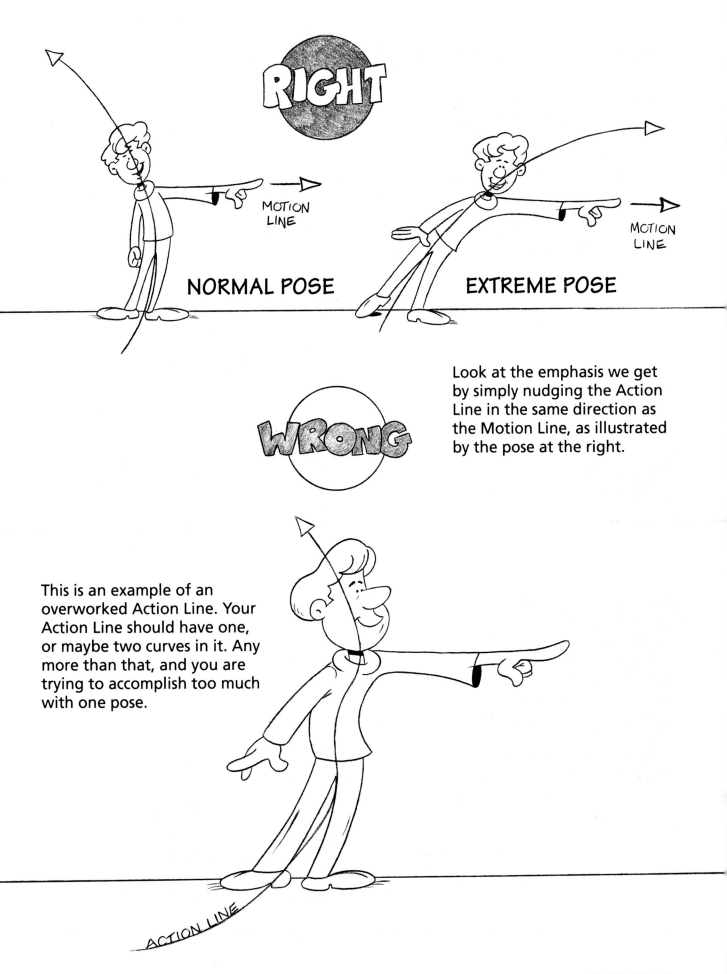

RIGHT

MOTION LINE

NORMAL POSE

MOTION LINE

EXTREME POSE

Look at the emphasis we get by simply nudging the Action Line in the same direction as the Motion Line, as illustrated by the pose at the right.

WRONG

This is an example of an overworked Action Line. Your Action Line should have one, or maybe two curves in it. Any more than that, and you are trying to accomplish too much with one pose.

ACTION LINE

The Great Outdoors

Whether your character is relaxing over a backyard barbecue or in the tug-of-war of his life, the Action Line will make your poses appear more natural. This weekend barbecue chef has an Action Line with a curve in it, to give his pose an easy, fluid feeling, while the embattled fisherman's Action Line is practically straight, and at a severe angle, because all the energy is going in that direction. (P.S., bet on the fish.)

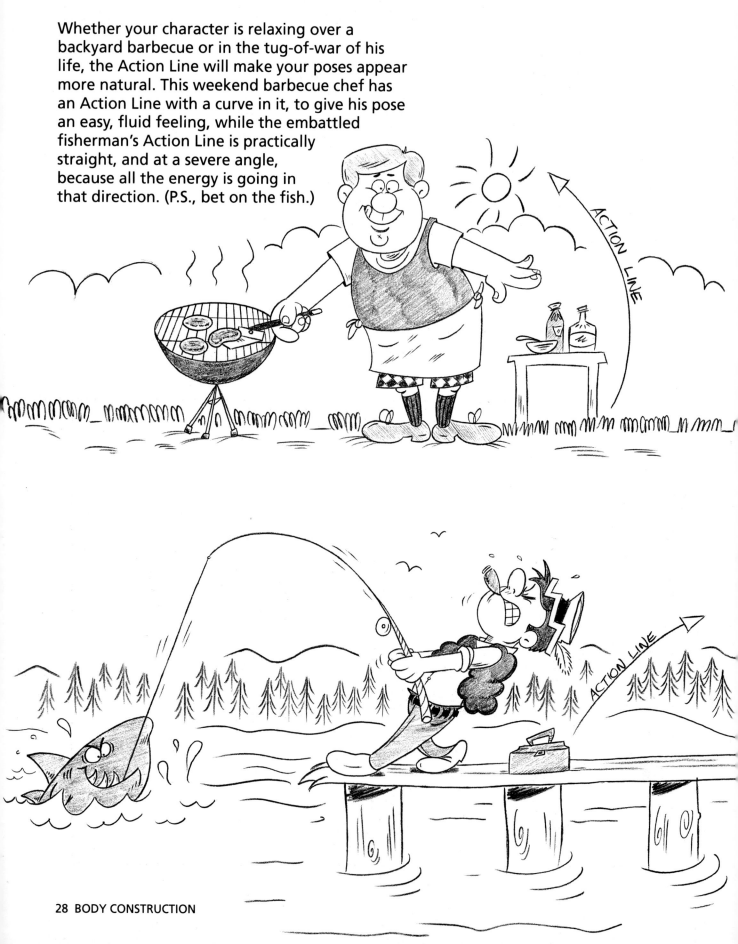

Clothing and Construction

Notice how clothing is left out of the construction stage. Never sketch the clothes when "roughing" out the body. Clothes are always the last item to be drawn.

Here I have chosen a classical woman's body with shapely legs because the subject is an athlete.

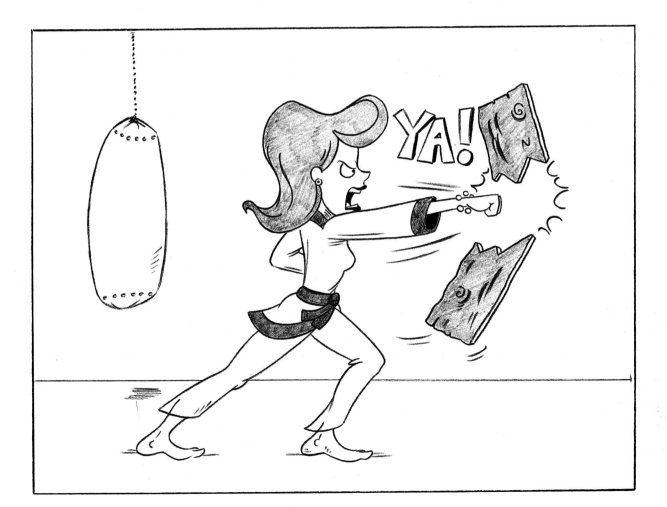

Stretch and Twist

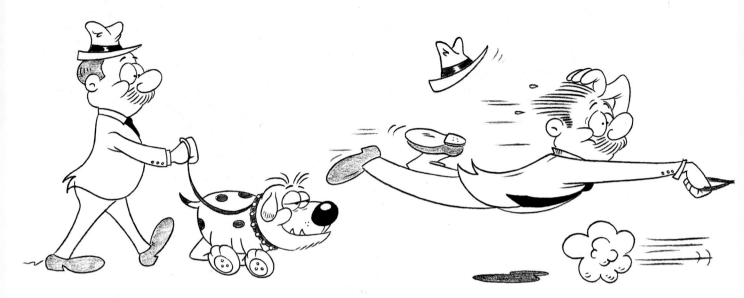

This fellow is taking his dog for a walk, when Fido sees a cat. Suddenly, the poor fellow is being taken for a ride! In the cartoon world, when someone is tugged, yanked, or pulled, the body is stretched to accentuate the action. We are playing with body inertia. The body doesn't want to follow. So it's being stretched before it finally snaps back into position. This is a key to successful animation.

Sometimes we really torture our poor cartoon characters. This water skier is not only being stretched, he's being twisted, as well.

Selective Stretching and Foreshortening

To emphasize a particular movement, sometimes we only need to stretch one body part. This is especially effective in the cartoon "sneak" walk.

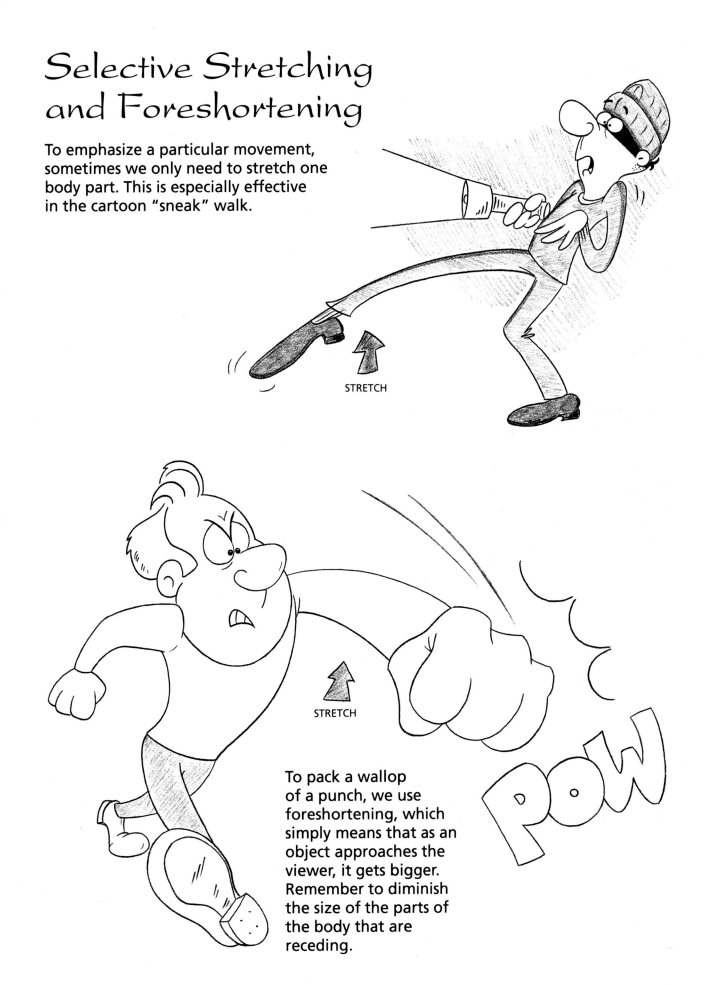

STRETCH

STRETCH

To pack a wallop of a punch, we use foreshortening, which simply means that as an object approaches the viewer, it gets bigger. Remember to diminish the size of the parts of the body that are receding.

HOW TO DRAW HANDS

After the face, the hands are the most expressive aspect of a cartoon character. Once you have mastered these hand drawing techniques, you will be able to use a variety of hand expressions to heighten the emotion of a scene.

Cartoon hands are different from real hands in that they have three fingers and a thumb. Why only three fingers? That's the age-old question. There is an answer for how it all got started, but the fact is that by now it's an institution. You may draw hands with four fingers and a thumb, if you like. There are some cartoonists who do just that, but you will be in the minority.

Three fingers and a thumb lead to more interesting hand poses. With four fingers, you're always trying to figure out what to do with that fourth finger, and the extra finger may distract the reader, who is accustomed to seeing a hand with only three fingers.

A real thumb has three bones in it. But a cartoon thumb has only two. Cartoon fingers only exhibit joints when they are bent. The lesson here is: Don't try to be too precise. Be bold instead. Remember that cartoon hands are more like mittens. They can grab and make funny gestures, but they will never be able to thread a needle.

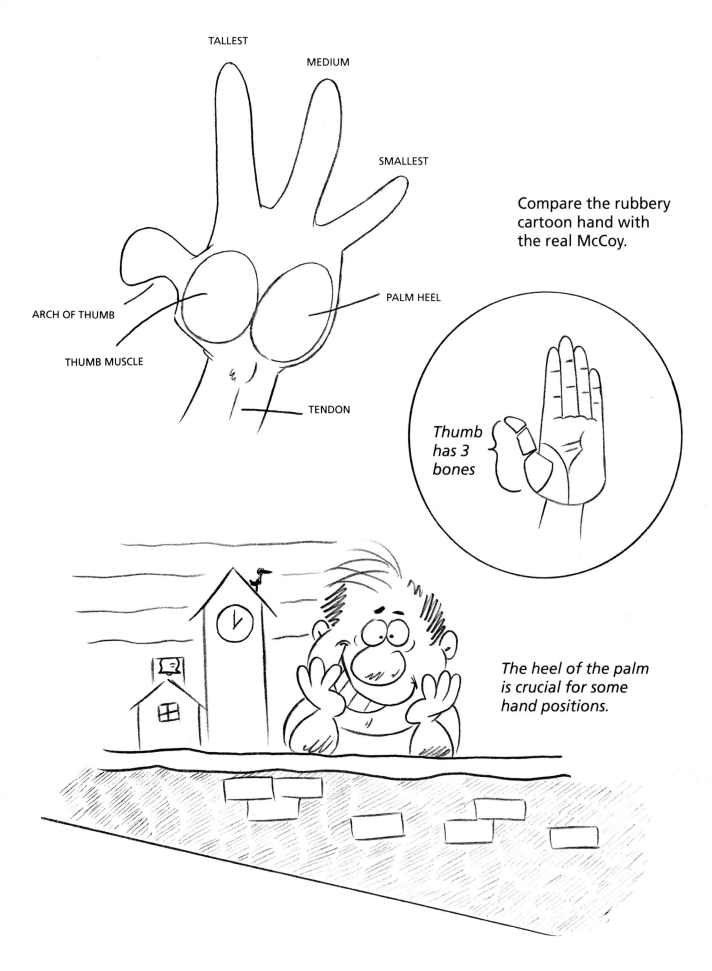

TALLEST

MEDIUM

SMALLEST

ARCH OF THUMB

THUMB MUSCLE

TENDON

PALM HEEL

Compare the rubbery cartoon hand with the real McCoy.

Thumb has 3 bones

The heel of the palm is crucial for some hand positions.

MORE HANDS.....

To become comfortable with drawing the hand, first familiarize yourself with it from all angles. Rotate your hand 360 degrees and examine it. Notice that it feels unnatural to keep the hand rigid as you turn it. Unless it is in a fixed pose, the hand should be fluid and relaxed, ever changing.

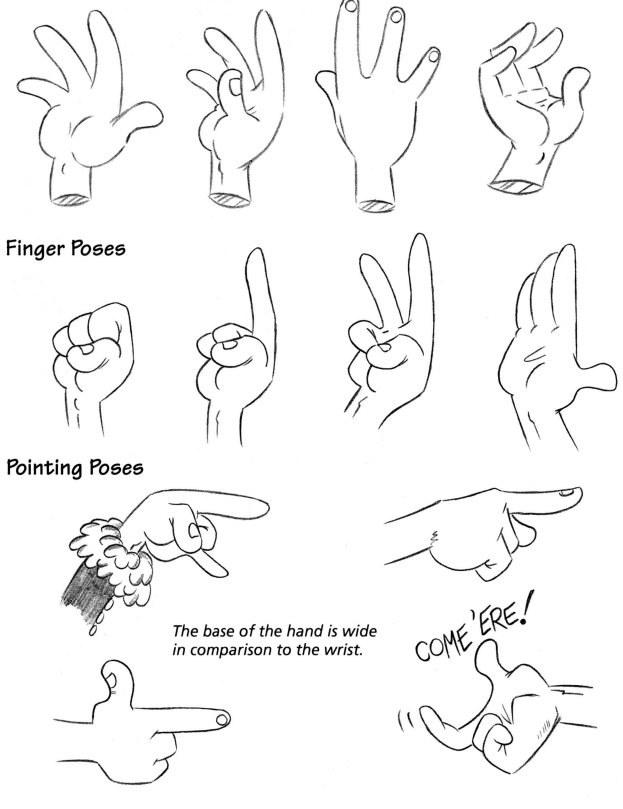

Finger Poses

Pointing Poses

The base of the hand is wide in comparison to the wrist.

COME 'ERE!

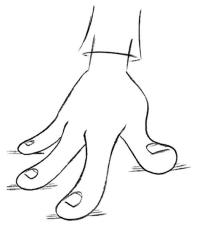

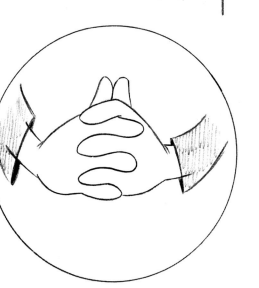

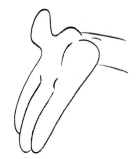

When drawing interlaced fingers, remember that as you draw one finger, you are creating the slot into which the opposing finger will fit.

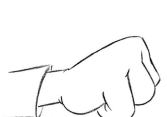

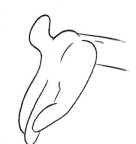

Balloon Hands

Broad, slapstick cartoon characters use "balloon hands"—hands that have fingers with no joints. They are less realistic and easier to draw than the hands we have been practicing thus far. Often balloon hands are gloved. This was the predominant way of drawing hands in the early days of animation. This was especially true when the animated character was an animal.

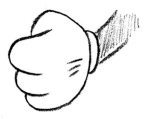

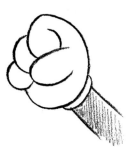

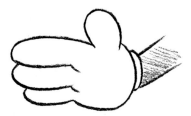

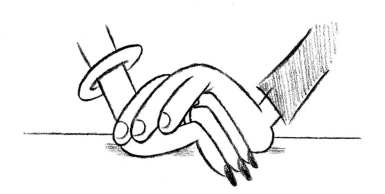

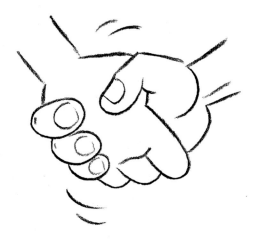

There are two basic positions for a hand resting at a person's side. The position on the left is tricky, because no matter how you draw it, the hand tends to look tense or stiff. The position on the right, with the fingers curling under, is far easier to draw and, in fact, more realistic.

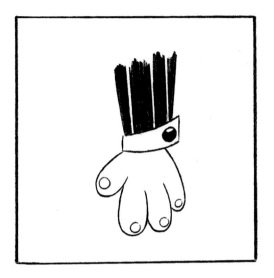
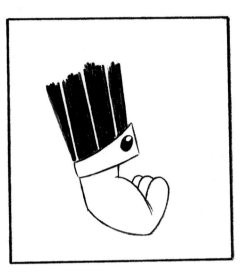

Women's hands are smaller than men's hands, and the fingers taper. A woman's hand can be glamorized an extra degree by adding darkened fingernails. Note that the fingernails are not an extension of the fingers, but extend the over the fingers.

The Culinary Arts

Gloved hands, once the standard method of drawing cartoon hands, are now less frequently seen. Today, gloved hands are used mainly to connote an attitude—such as "fancy," "refined," or "proper."

Not exactly from the book of Etiquette.

"Pinkies up" always adds humor.

Hiding Hands

Hey, sometimes cartoonists get lazy. Suppose you are drawing a composition with many people or animals in it, and you don't want to spend the time drawing each hand. What do you do? You pick up this book and flip to this chapter. Here are some examples:

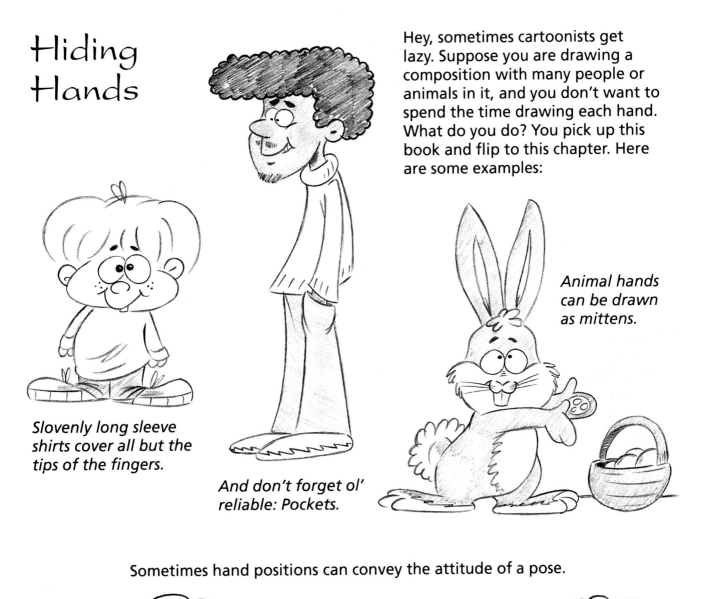

Slovenly long sleeve shirts cover all but the tips of the fingers.

And don't forget ol' reliable: Pockets.

Animal hands can be drawn as mittens.

Sometimes hand positions can convey the attitude of a pose.

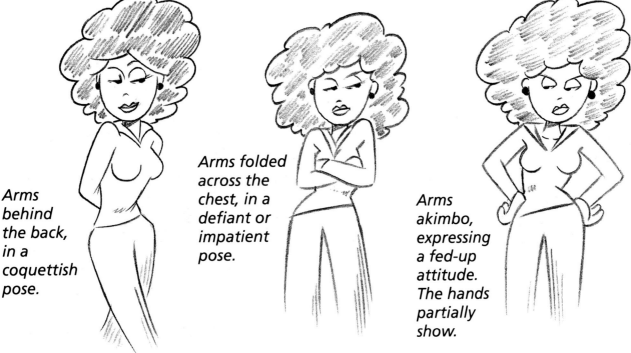

Arms behind the back, in a coquettish pose.

Arms folded across the chest, in a defiant or impatient pose.

Arms akimbo, expressing a fed-up attitude. The hands partially show.

THE CASTING DEPARTMENT: COSTUMES AND PROPS

Included in this section on casting, costumes, and props are the techniques used by professional cartoonists to create specific identities for their characters. By referring to this section, you can build an ensemble of characters for your own comic strip or for an animated film.

Most beginning artists and cartoonists believe that you must draw a character to suit a particular time in history. For instance, the thinking goes, a cowboy should have rugged features, while a cave man should have a low forehead. This is not at all true. In fact, the humor of cartoons comes from the irony of thrusting a modern, meek-looking character into identities and settings that are far beyond his physical attributes.

By merely costuming your hero in different ways, you make him convincingly become a variety of characters. By introducing props and other supporting elements from a specific historical period into the hero's surroundings, you have created another world that is believable.

To demonstrate this, I have taken a meek, contemporary looking character and transformed him through the ages, to show how he appears in different periods of human development.

You may copy this hapless fellow in his various incarnations, or use a character that you develop yourself.

Here is an adaptable character that will serve our purposes well. I have built his head by using different planes. The many slopes of his head create that meek look that I am seeking.

A thin body is easier to costume than a fat body, because you can pile more onto it. In addition, a thin body allows your eye to focus on the costume, and doesn't compete for your eye in the way that a big body does.

Backdrops, Props, and Supporting Characters

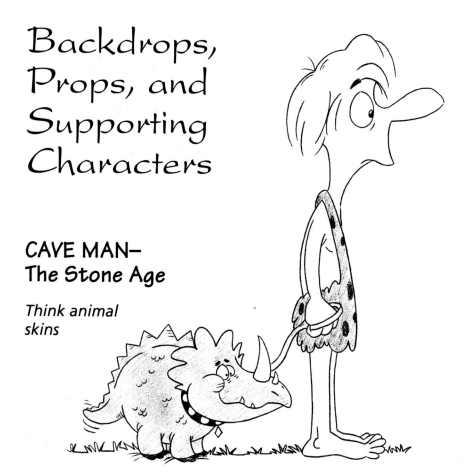

CAVE MAN–
The Stone Age

Think animal skins

Stone tools
Caves
Cave paintings
Bones
Fire
Clubs
Vines, for swinging
Wheel
Volcanoes
Waterfalls
Dinosaurs
Hot springs
Shooting stars

ROMAN–
The Roman Empire

Think toga

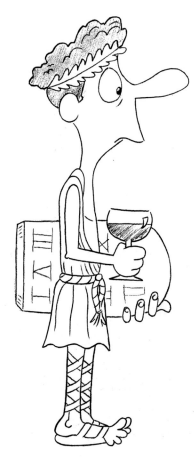

Large urns
Coliseums (arenas)
Lions
Large feather fans
Pillows and cushions
Fountains
Stone writing tablets
Slaves
A philosopher
A speech writer
Harps
Statues
Baths
Grapes and fruit
Columns
Scrolls

ARABIAN KNIGHT– Persia

Think sword and headdress

Magic lamps
Genie
Evil warlords
Jewels
An oasis
A mirage
Horses
Flying carpets
Cyclops

Veils, for women
Caves with secret passageways
A used camel salesman
Snake charmers
A marketplace
Quicksand
A harem
Treasure

VIKING– The Old World

Think horn hat

Plunder (the loot)
Heavy meats
Feasts
Pigs and livestock
Battle axes
Torches
Warriors
Bonfires

Chalices
Wood cabins and barracks
Shields and swords
Oar-driven boats
Mermaids
King Neptune

KNIGHT–
The Dark Ages

Think heavy metal

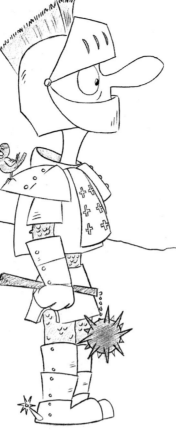

A castle
Moats with crocodiles
A royal family
A wizard
Wands
Potions
Swords, shields, and maces
A drawbridge
Dragons
Feasts
Gypsies
Catapults
Horses
Peasants
Squires
Court jesters
Dungeons
A masked executioner
Donkeys, geese, and mice

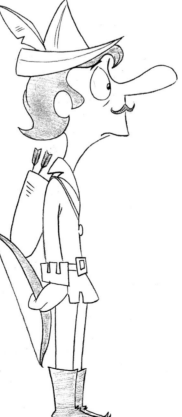

ROBIN HOOD–
Merry Old
England

Think leotards

Tents and flags
Fencing swords
Castles and towers
Maidens
Bridges over streams
A forest
Villages and shops
A cobbler
Cheese wheels
Roving carnivals
Fairies
The king's tax collector
A troll
Crossbows
Arrows
Horses

PILGRIM–
The New World

Think tidy

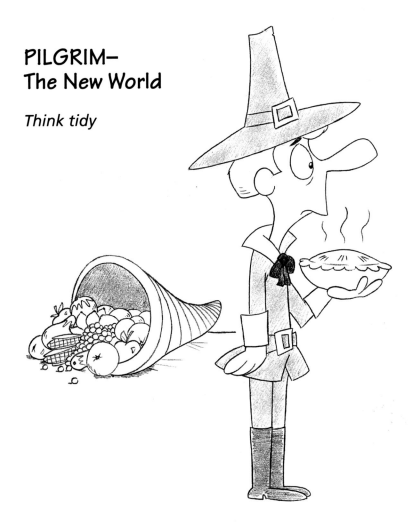

A turkey
Stockades
Muskets
A church
A minister
Newlyweds
A small schoolhouse
A teacher
Wooden furniture
The town crier
The town drunk
Witches
Log cabins
Wells for water
Quilts
A courtroom
A blacksmith
Horses and plows

PIRATE–
The Seven
Seas

Think scruffy

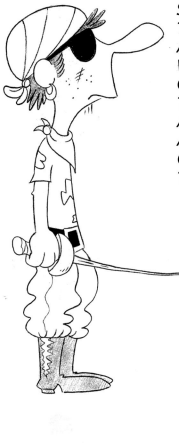

Ships
Tropical ports
A treasure map
Walking the plank
Cannons
The brig
A parrot
A telescope
Crows and sea gulls
The captain's cook

A ship's lookout
 point
Sails
Portholes
Bunk beds
Mops, for swabbing
 the deck
Anchors
Knives and guns
Fencing swords

COWBOY– The Wild West

Think rawhide

Horses with saddles
Mules
Troughs
A saloon
Bartenders
Barmaids
Sheriffs
Prospectors
A hangman's scaffold
A blacksmith's shop
Rifles and six-shooters
Trains
Safes
Jails
Guitars
Barns

Stagecoaches
Snake oil salesmen
A general store
Barber shop
Bandits with ponchos

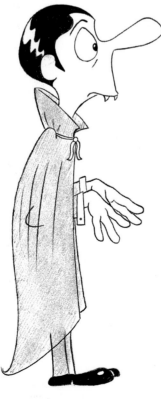

VAMPIRE– Monsters and Evil Beings

Think teeth

A full moon
Creepy castles
Lightning
Hands holding
 torches
A laboratory
Bats
Cemeteries
Haunted houses
Spider webs
Horse-drawn
 carriages

Coffins
Ravens
Forests and fog
Secret doorways
Amulets
Gypsies
Zombies
Ghosts
Mummies
A mad doctor
Igor, the doctor's
 helper

NATIVE AMERICAN—
More Wild West

Think feathers

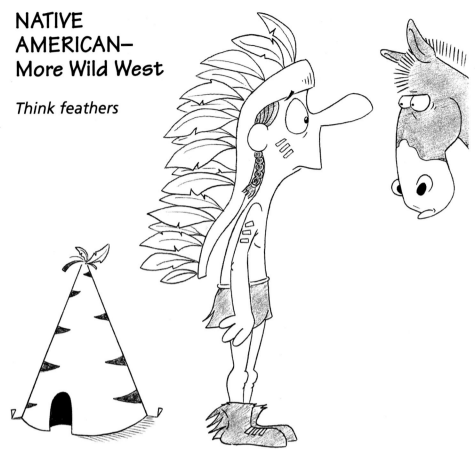

A medicine man
Campfires
Smoke signals
A peace pipe
Beads
Drums
A Native American
 princess
A chief (her dad)
Her boyfriend
Corn
Mountain trails
Waterfalls
A wise man
A herd of buffalo
Animal skins
Bows and arrows
Rifles
Horses
Tomahawks
Totem poles

MODERN MAN—
Today

Think functional

Just look around you.
The world is your
notebook.

THE ART OF CHARACTER DESIGN

If art is the joy of creation, then character design is the joy of cartooning. Creating an endless stream of new characters sounds like an impossibility to the amateur cartoonist, whose only hope is to find one character that is worth keeping out of the "round file."

So how do you invent new characters?

Most people rely on inspiration or luck. But you can wait around a long time for luck to strike. And if you find yourself in the middle of a traffic jam with tons of inspiration and no pencil handy, well, then you're out of luck, aren't you?

To develop new characters, you must approach drawing differently. The secret is that you are not so much "inventing" new characters as you are "discovering" them, hidden in the old.

Instead of viewing the face as a sculpture, with its pieces and parts set in stone, we are going to think of the face as a *chess board*. The features are the pieces, which can be moved to create new characters. Each time we move a piece—or a feature—the entire face takes on a slightly new look.

Be willing to experiment, to make characters that look "wrong," in order to find the ones that look just right. You will see that what starts out as trial-and-error will soon become second nature to you. And you will find that you have developed a tool for constantly inventing new characters that is fun to use, efficient, and effective.

Think in terms of areas of the face. There is a general range for the eyes, nose, and mouth. Within these areas, there is a lot of room to adjust the positioning of the features.

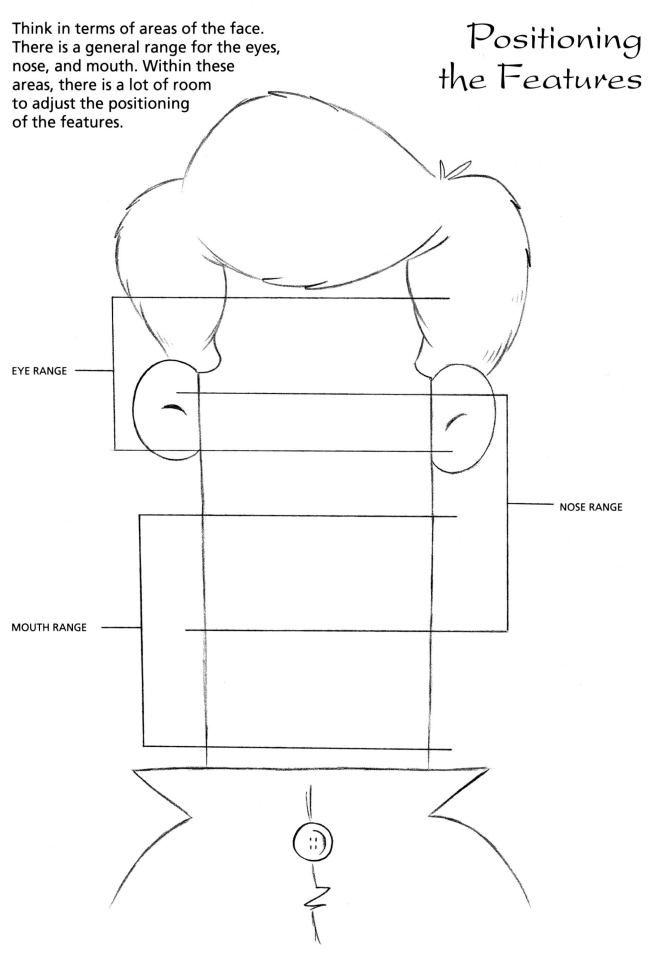

EYE RANGE

NOSE RANGE

MOUTH RANGE

EYES

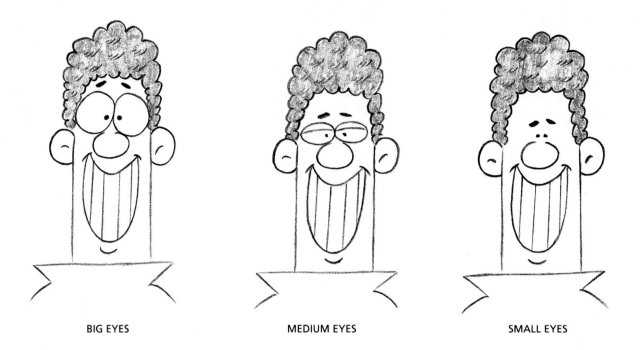

BIG EYES MEDIUM EYES SMALL EYES

By adjusting the shape of the eyes and the nose, you can develop a stylized alternative to an existing character. To create an entirely new character, we will have to go further.

NOSE

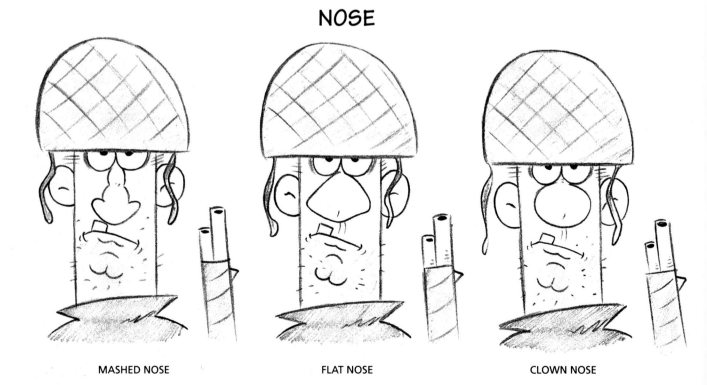

MASHED NOSE FLAT NOSE CLOWN NOSE

MOUTH

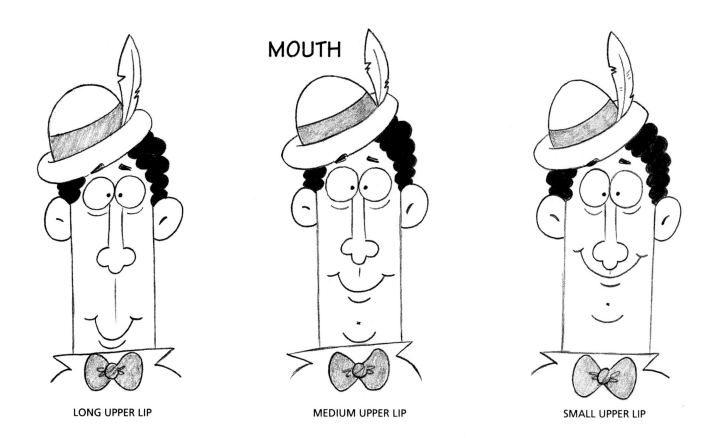

LONG UPPER LIP

MEDIUM UPPER LIP

SMALL UPPER LIP

We adjust the mouth by moving it up and down within the "Mouth Range." This is done by increasing or decreasing the size of the upper lip.

Hair is the most powerful single ornament in changing a character's identity. Be bold.

HAIR

CURLY FLAT TOP

NATURAL, WITH PROP

CRAZY, JET BLACK

Changing More Than One Element

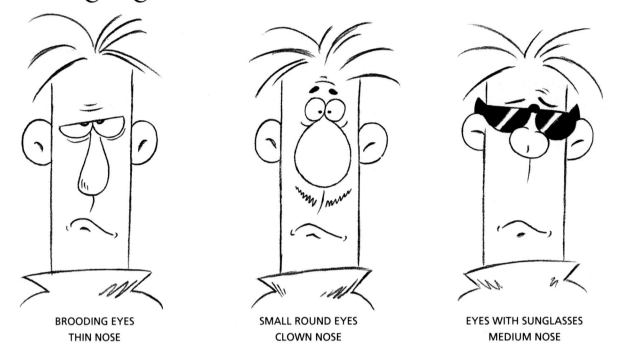

BROODING EYES
THIN NOSE

SMALL ROUND EYES
CLOWN NOSE

EYES WITH SUNGLASSES
MEDIUM NOSE

In these examples, we have changed *two* elements on each of the characters: the eyes and the nose. As a result, the characters are no longer merely variations of one another, but are beginning to assume separate identities.

The characters in the bottom row all have *three* new elements, and have assumed totally new identities. In order to create strikingly new characters, you must alter at least three basic elements. Hair counts as one element.

You can create new characters without ever touching the overall head construction. The faces we have been using thus far are based on a cylinder, which serves as an excellent canvas for character designs.

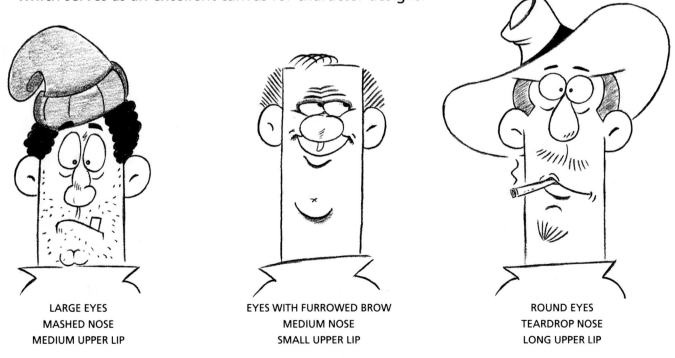

LARGE EYES
MASHED NOSE
MEDIUM UPPER LIP

EYES WITH FURROWED BROW
MEDIUM NOSE
SMALL UPPER LIP

ROUND EYES
TEARDROP NOSE
LONG UPPER LIP

Changing the Head Construction

You can also create new characters *without changing any basic features* (eyes, nose, mouth, and hair), but by merely varying the size of the skull in relation to the jaw. This may seem easier, but it is actually a bit trickier. Slightly more drawing skill is required in adjusting the basic head construction. However, once you master this step in character design,

you will find that the possibilities are limitless, and your drawings will take on a new authority and flair.

Eventually, you should try to combine what you now know about varying the features with what you are learning about varying the construction of the head. That is the character design secret of the professional cartoonist.

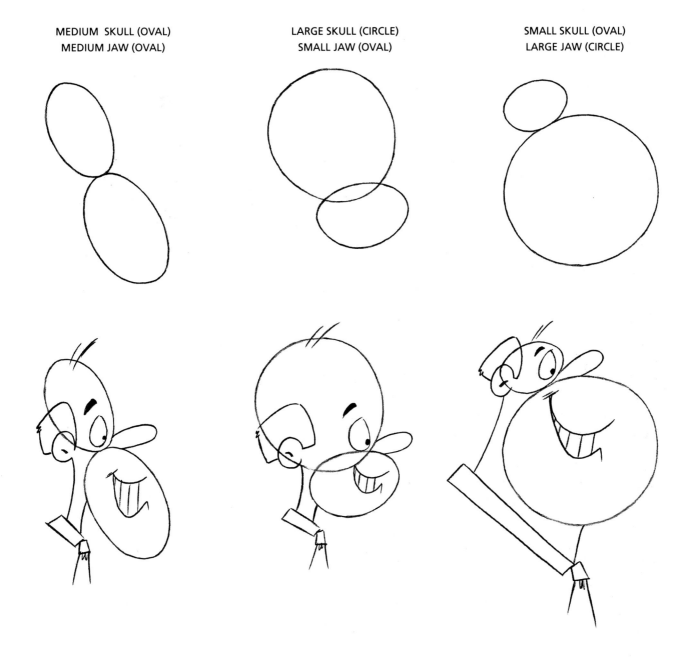

MEDIUM SKULL (OVAL)
MEDIUM JAW (OVAL)

LARGE SKULL (CIRCLE)
SMALL JAW (OVAL)

SMALL SKULL (OVAL)
LARGE JAW (CIRCLE)

New Shapes

Sometimes it's wise to try out several head shapes before settling on one. Try these variations...

VASE

A CUT-OFF CONE

BULLET

OVAL

CYLINDER

The Finished Drawings

Trace over your rough drawing, leaving out the sketch marks.

Posture

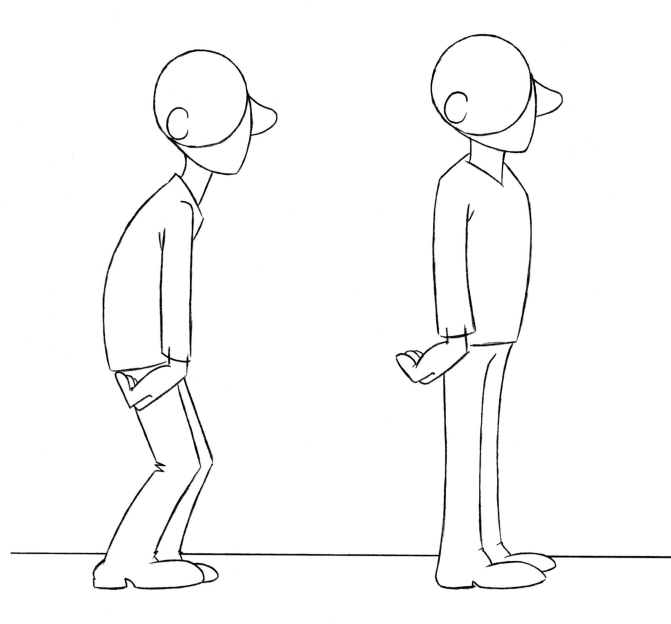

Posture is a character trait. A person with a slumping posture appears weak and indecisive. The same person with good posture appears determined; he or she looks like a leader. Make a conscious choice about posture when designing your character.

Body Types

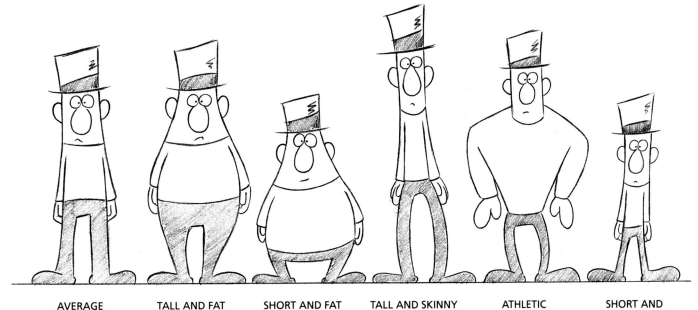

AVERAGE TALL AND FAT SHORT AND FAT TALL AND SKINNY ATHLETIC SHORT AND SKINNY

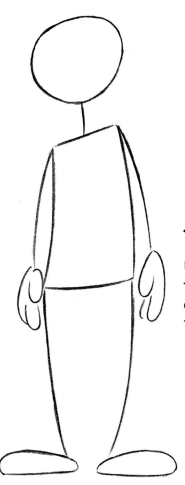

The Elastic Stick Figure

Use this adaptable stick figure to design bodies. The torso can be stretched, thinned, or fattened to suit your needs.

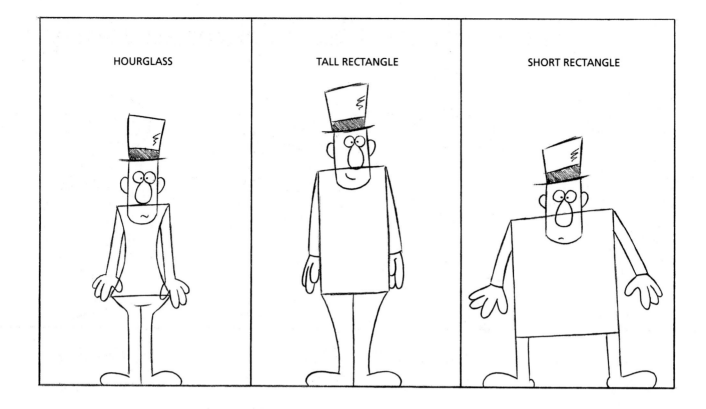

HOURGLASS

TALL RECTANGLE

SHORT RECTANGLE

Rectangles can be turned into hourglasses and squares.

Circles can be turned into tall or short ovals.

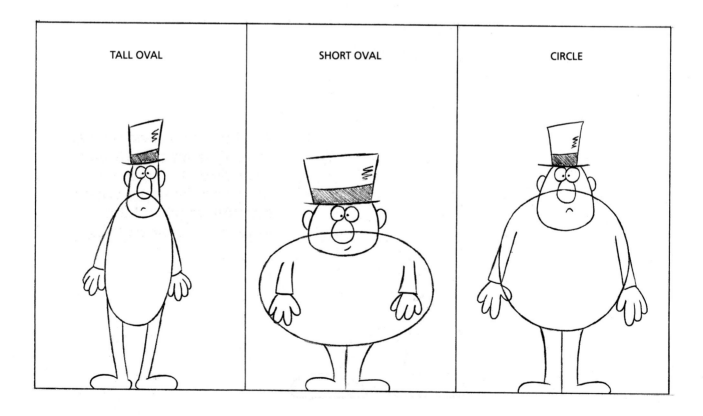

TALL OVAL

SHORT OVAL

CIRCLE

The Popular Pear-Shaped Body

 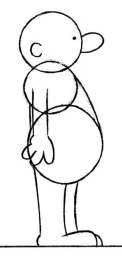 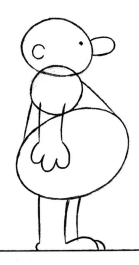

The Big Gut

Slumping Posture

The Big Chest

Upside Down Pear

The Average Pear-Shape

Small chest, medium hips

The Fat Pear

Good posture

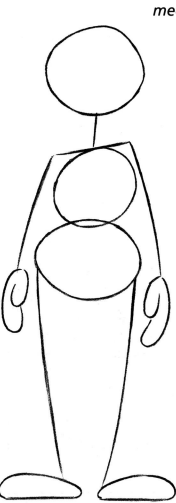

As with the face, we can get more varieties of body types if we divide the torso into two parts: the upper body (chest/rib cage) and the lower body (stomach/hips).

ANIMAL CONSTRUCTIONS AND SIZE CHARTS

Animals have made some of the most popular and enduring cartoon characters of all time. For cartoonists, drawing animals is, in a word, *fun*.

Each animal is built differently. Try to make the personalities of the animals you draw mirror their physical attributes. One example of this would be to portray a ravenous crocodile. You will find that this helps your cartoon because you are highlighting the animal's basic nature, which in this case would be illustrated by the size of the crocodile's mouth and teeth. Later on, to add more humor, you can draw *against type*, which means that you would give the animal a personality that is directly the *opposite* of its natural physical attributes, such as a vain, diet-conscious hippo, etc.

By now, you know enough about how to draw bodies and faces to follow these intermediate animal constructions easily.

The animal size charts should be useful to you as you begin to include more than one character in your drawings. Remember, the charts do not convey the *actual* sizes but, rather, the relative *cartoon* sizes. A real tortoise comes up to a person's ankle. If you were to draw a cartoon of a person and a cartoon tortoise in the same panel and failed to adjust the sizes for cartoon purposes, the person would look huge and the tortoise would all but disappear.

Think of Bugs Bunny and Elmer Fudd. A real rabbit is only slightly taller than a tortoise, but Bugs, as we all know, stands eye-to-eye with his old nemesis, Elmer Fudd.

These sizes are meant as a general guide. They can be varied for emphasis and personal taste.

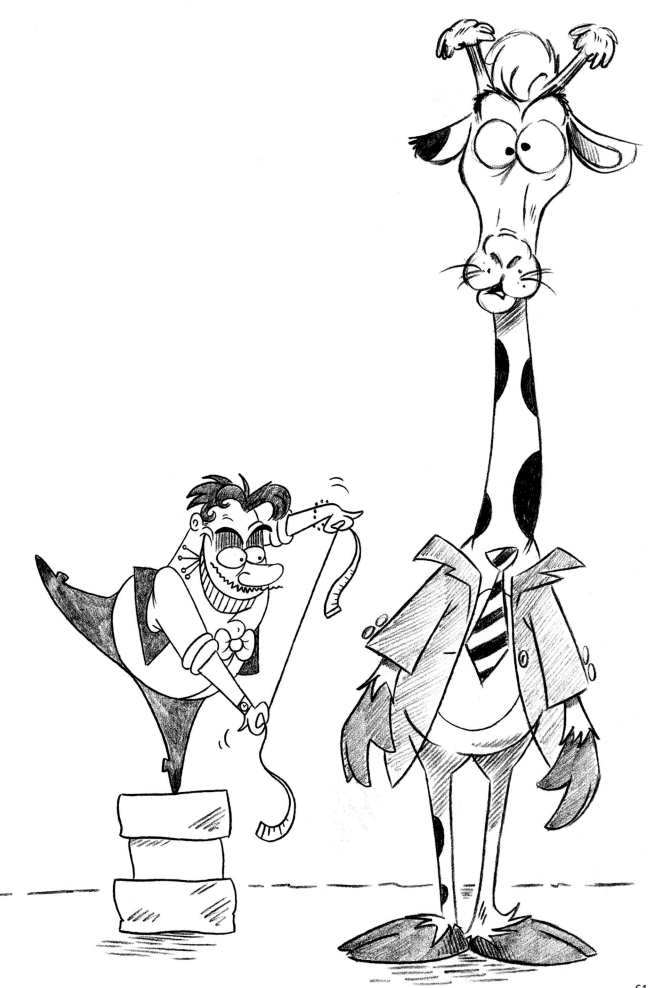

BEAR

Big head, distinctive snout, big belly, and powerful front paws. Short tree trunk-like legs.

PENGUIN

Big cheeks, a round head, a squat little body, and chubby thighs. Penguins wear "tuxedos."

HORSE

Muscular, strong animal. The torso is barrel shaped. The upper legs are pure muscle. The jaw is pronounced. Never give a horse a skinny neck.

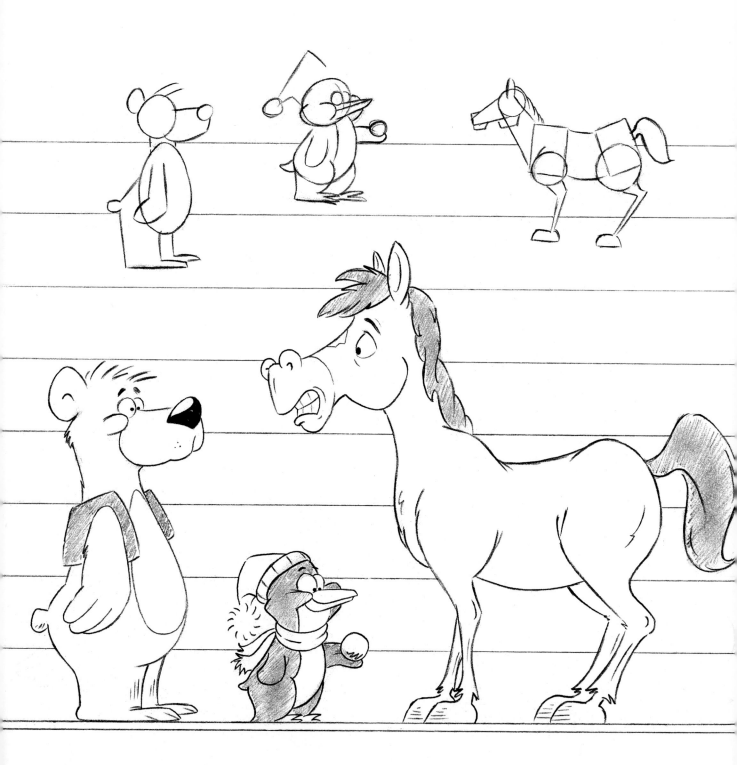

SQUIRREL

Big bushy cheeks. Small nose and always big front teeth. Pear-shaped body.

BULL

Pronounced nose and sharp horns. Powerful jaw. Tiny ears. Huge chest that tapers dramatically to a narrow waist. Short legs.

SNAKE

Narrow face. Forked tongue. Slinky, thin body that coils. Markings. Fangs show when mouth is open.

TURKEY

Tiny skull for pea-sized brain. Scaly neck. Fat body with a long droopy tail. Messy feathers.

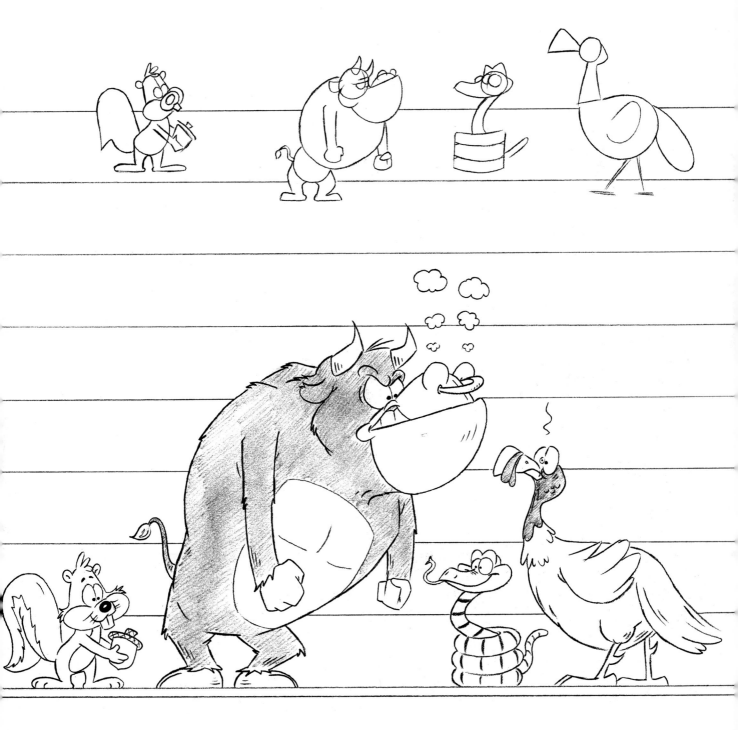

HIPPO

Big skull and snout. Small eyes. A refrigerator for a body. Stubby, elephant-like "arms" and legs. Hairless and wrinkly.

PIG

Think circles and chubby everything, including double chin. Big round snout. Floppy ears. Hooves and coiled tail.

CROCODILE, ALLIGATOR

Crocs have pointed snouts, while alligators have flat snouts. Long jaws filled with sharp teeth. Long, plumpish two-toned body. The top is bumpy, the bottom is marked by long striations.

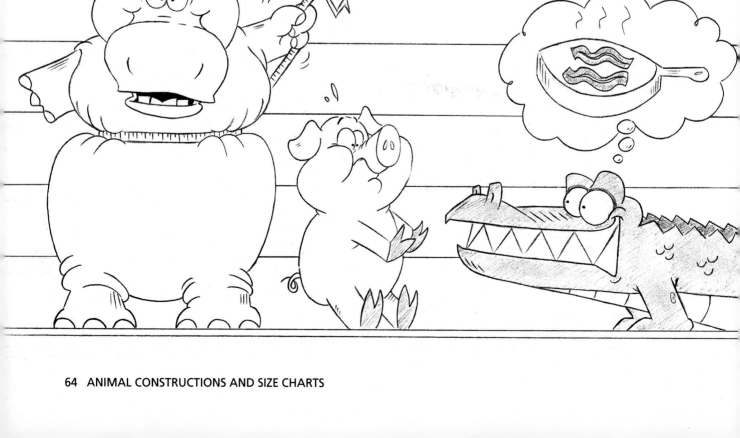

BAT

A squirrel with fangs and creepy wings.

MOUSE

Long snout. Whiskers are a must. One or two buck teeth. Big ears, squat body, and long tail.

LION (standing upright)

Shaggy mane, big snout, and large chin. Whiskers. Round, "people-type" ears. A "person-type" body, but watch those claws!

LION (on all fours)

Most cartoon animals that are drawn to stand upright on two legs can also be drawn on all fours. Note how the height must change.

FOX

Narrow snout, wide face. A thin, short body, with black legs and a bushy tail.

WOLF

Big head, and slightly larger in all respects than a fox. Snout not as pointy. Legs retain their furry appearance and do not taper as severely as fox's.

TORTOISE

Droopy eyes, parrot-like nose. Shell curves to mimic bad posture. Elephant-like "hands" and feet. Markings.

MAN

Deranged eyes; obviously a dangerous species. Flexible fingers, for drawing cartoons. Long legs, for walking back and forth to the 'fridge.

SKUNK

Big bushy tail with very distinctive markings. Bushy head, pointy snout, squat body, and surprisingly strong legs.

ELEPHANT

"Dented" upper head, huge cheeks, and long, curving trunk. Floppy ears Tremendous body. Wrists relaxed. Big nails in "hands" and feet.

GORILLA

Powerful neck and jaw and low brow. Rounded shoulders and a well-fed stomach. Short, bowlegged. A stub of a tail.

CHIMP

Wide, goofy mouth. Big ears. Small body and long limbs. Oversized hands and feet, and a long, winding tail.

PRINCIPLES OF LAYOUT

Now that we've gotten a good handle on drawing cartoon characters, let's make a world for our lovable rascals to inhabit. This is where layout comes in.

What is layout?

It simply means: where stuff goes. Where you place a character on a page is a layout decision. What kind of background you give him or her is also a layout decision. Should the character be placed near the background, or near the foreground? And what effect will each placement have on the reader? All these are layout decisions.

Arranging the background, character(s), dialogue balloon, and foreground so that they interact to promote a single idea is the whole point of layout.

Sounds like a lot? It would be if we had to consider every element every time we drew. Happily, this is not the case. Most often, only a few well-placed props are necessary to create the desired atmosphere for a scene. This section is intended to show you how to *economically* lay out your cartoons for maximum effectiveness and drawing ease.

Without the principles of layout, our characters would have no roads to stroll down together. There would be no clouds in the sky or sun up above. This chapter marks a turning point in our journey together. You are now the director of your own show. You are no longer drawing faces and bodies in the abstract, but beginning to create vivid scenes in which your characters are the players.

Before we begin, here is a note about drawing props and backgrounds...

Some beginning cartoonists make the mistake of trying to draw props and backgrounds realistically, with painfully exacting detail. Resist this impulse. In the same way that a cartoon face is an *interpretation* of a real face, your backgrounds and props should be your own interpretation of the real things. In other words, have fun with them. Exaggerate them. Simplify them. A dollar bill becomes a piece of paper with the "$" sign on it, rather than George Washington's exact likeness. Keep everything a cartoon, so as not to confuse styles.

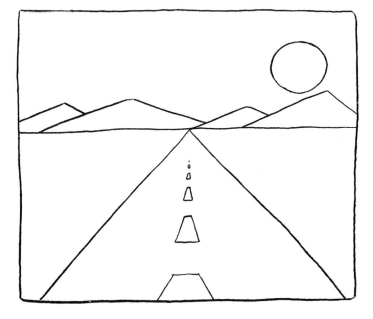

Creating Distance

THREE ROADS TO INFINITY

To create the illusion of depth, we need to suggest distance. Distance is the length between objects, in this case, between the foreground and the background. To make the picture compelling, there must be something that *draws* the reader's eye from the near object to the far object. The *road* serves as an excellent tool for this purpose. It's a cartoon standard. Can you feel how each road shown draws you into the distance?

Winding Road

Make sure that all the roads you draw narrow to a pinpoint at the horizon line. The horizon line is the point where the sky meets the ground.

Straight Highway

Notice that the higher the sun is in the sky, the smaller it appears; and the lower in the sky, the larger it appears.

Zigzag Road

A cartoon favorite. The turns don't have to be as sharp as they are drawn here. You can soften them into curves.

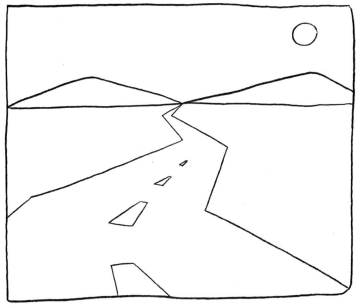

Overlapping to Create Depth

THE ROLLING HILLS OF CARTOON LAND

Another way to create depth is by *overlapping*. An object that is overlapped by another is *further* away from the reader.

The man who is overlapped by the hill is further away from the reader. The distant hills are overlapped by the nearer hills. Objects in the distance get progressively smaller.

The hill that we have introduced between the two men adds more of a feeling of depth than if they were standing apart on a level surface.

Shifting Foreground and Background for Emphasis

The *nearer* an object is to the reader, the greater its impact. Conversely, the farther away an object is from the reader, the less impact it has.

THE DREADED PHONE CALL

The man's reaction is clearly emphasized in this scene. The phone, in the background, is just used as a cue.

The phone and man share equal weight. Now we are beginning to pay more attention to that phone call, and wondering who it might be.

The phone steals the spotlight. It is the star of the scene, so much so, in fact, that I have had to broaden the man's expression just to keep him alive in the picture. In a close-up, the cabinet and phone require more detail.

The Importance of Props

A simple prop, like a fence, can define an otherwise vague relationship. The couple on the top might be boyfriend and girlfriend, or strangers who have just met. By merely erecting a fence, below, we have defined them as *neighbors*.

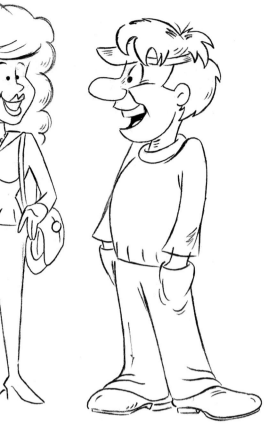

The fence is a long horizontal plane. Horizontal planes, like horizons, convey a sense of calm and tranquility, which serves this scene well.

Grass is indicated by a straight line broken by clumps of grass.

Reference Points Help Identify Characters

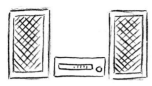

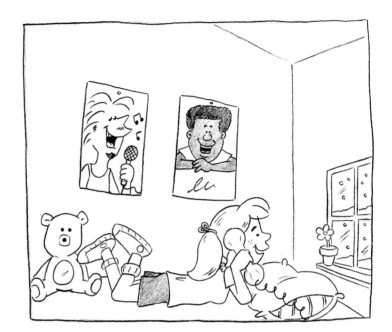

This is obviously a teenager's room. But what makes it obvious? The posters and teddy bear. Search your mind for reference points in the form of props. Think of an elderly person. What comes to mind? A rocking chair. A cane. A quilt, perhaps. Props do for scenes what costumes do for people.

Here's a movie mogul in his screening room. The props are so strong that no background is needed. Note the lack of a defined floor or ceiling. This is called a "floating" background. It is highly stylized and should be used judiciously.

Symmetry

Symmetry is created by distributing equal weight to all parts of the picture plane. Things that are symmetrical have a feeling of ease about them. Things that are asymmetrical have a feeling of tension. Tension is often a good thing. It can add drama or humor. The more asymmetrical, the more tension. Let your subject determine whether the layout should be symmetrical or asymmetrical, and to what degree.

CENTER

CENTER

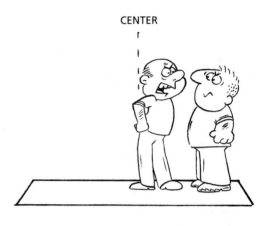

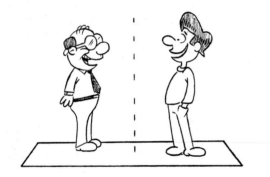

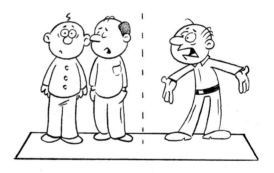

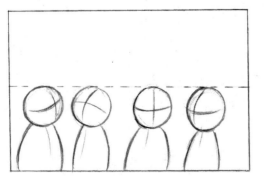

SYMMETRY

VARYING THE HEIGHTS OF CHARACTERS IN A SCENE OR COMIC STRIP IS ANOTHER WAY OF AVOIDING A SYMMETRICAL LOOK.

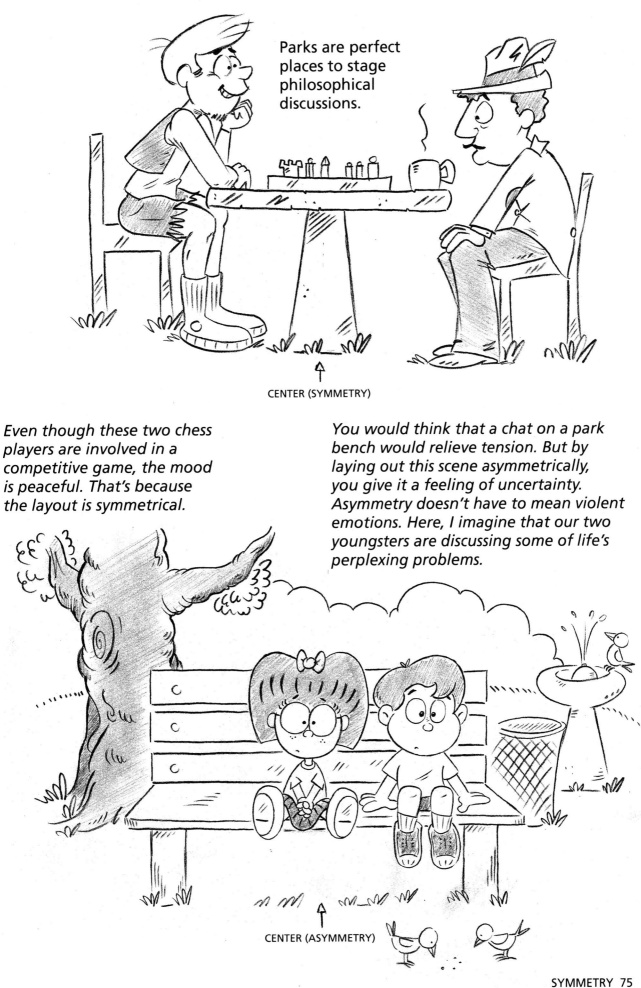

Parks are perfect places to stage philosophical discussions.

CENTER (SYMMETRY)

Even though these two chess players are involved in a competitive game, the mood is peaceful. That's because the layout is symmetrical.

You would think that a chat on a park bench would relieve tension. But by laying out this scene asymmetrically, you give it a feeling of uncertainty. Asymmetry doesn't have to mean violent emotions. Here, I imagine that our two youngsters are discussing some of life's perplexing problems.

CENTER (ASYMMETRY)

Templates for Backgrounds

Oval **Puddle** **Half Circle**

Sloppy Cone **Slanted Square**

Sometimes you'll want to stylize the background by only showing part of it, allowing the rest to disappear. That's where a background template comes in. It prevents the page from becoming cluttered, and focuses the reader's attention where you want it.

First sketch in your background, then choose a template shape. Draw an invisible line around your background in the form of the shape you've chosen and erase everything outside of it. Experiment with several of these shapes.

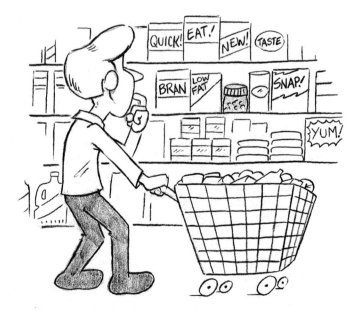

See how natural it looks?

The Doghouse: A Cartoon Classic

Some backgrounds are so appealing
and familiar that all that is needed
is one drawing to set the scene.

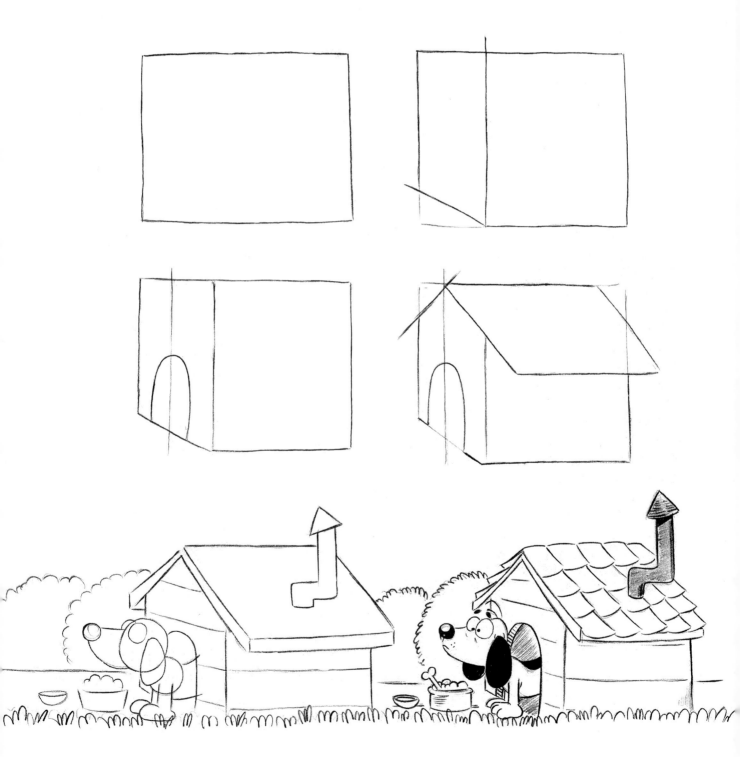

Corners Are For Fun!

If there's a rule about corners,
it's this: Whatever is around the
bend has got to be a surprise.

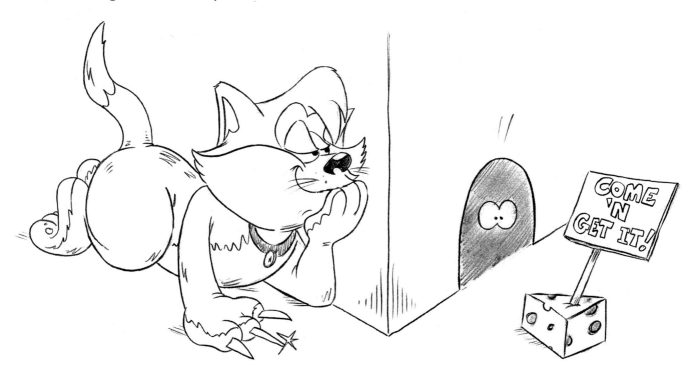

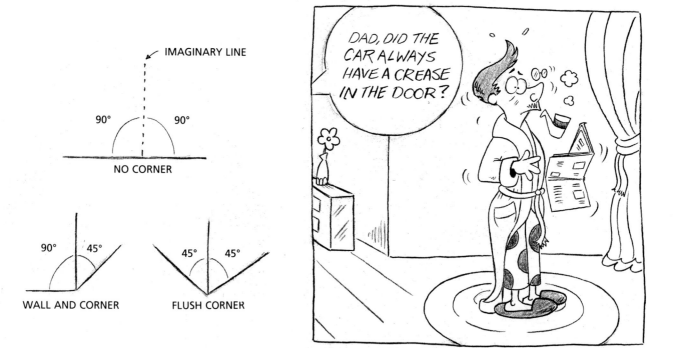

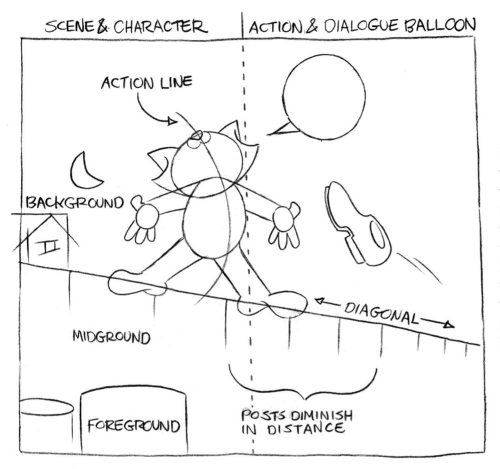

SCENE & CHARACTER | ACTION & DIALOGUE BALLOON

ACTION LINE

BACKGROUND

II

MIDGROUND

FOREGROUND

DIAGONAL

POSTS DIMINISH IN DISTANCE

Breaking Up the Page

By clearly separating the various parts of the layout in your rough sketch, you will make the finished drawing much clearer. This works even when there are many elements simultaneously at play.

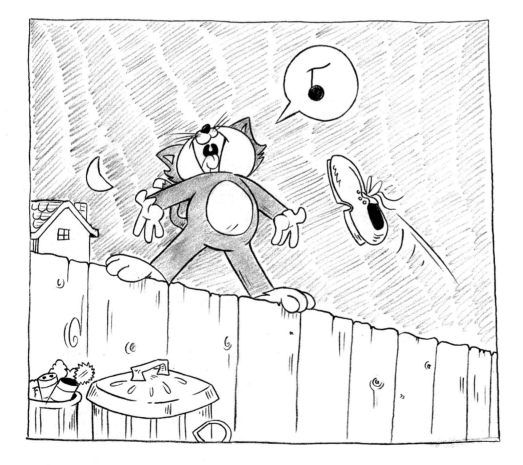

Low Angles

By moving your vantage point low to the ground, you make the object above you appear huge and awesome.

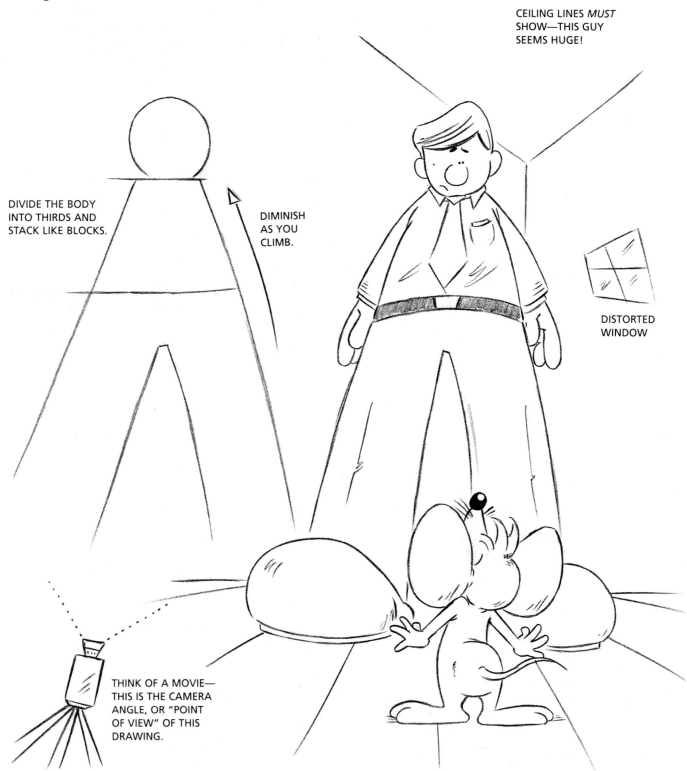

DIVIDE THE BODY INTO THIRDS AND STACK LIKE BLOCKS.

DIMINISH AS YOU CLIMB.

CEILING LINES *MUST* SHOW—THIS GUY SEEMS HUGE!

DISTORTED WINDOW

THINK OF A MOVIE— THIS IS THE CAMERA ANGLE, OR "POINT OF VIEW" OF THIS DRAWING.

High Angles

This is also known as the "Bird's Eye View." Here, we move the vantage point up above the action, looking down at the object, making it appear small and weak. High and low angles comment on the emotional content of a scene

CAMERA ANGLE—
POINT OF VIEW

1/3

1/3

1/3

INCREASE
SIZE AS
YOU CLIMB

Dungeons and Lock Boxes:
Two Other Cartoon Classics

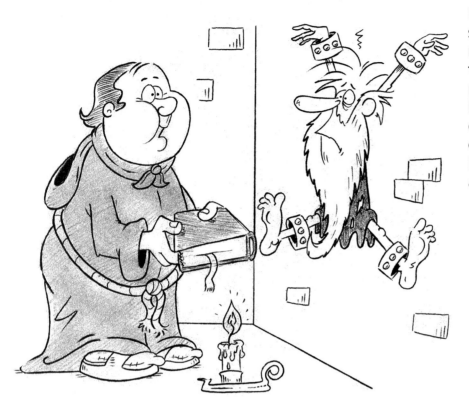

Here we have a very popular setting for cartoons set in medieval days. Notice that the walls are the most prominent feature of the backgrounds. They can be drawn either as a receding corner, as in the top illustration, or as a flat wall, as in the bottom cartoon.

Notice that some of the humor is derived from contrasting the size of your characters. The prisoner is always skinny, while those guarding him are always rotund.

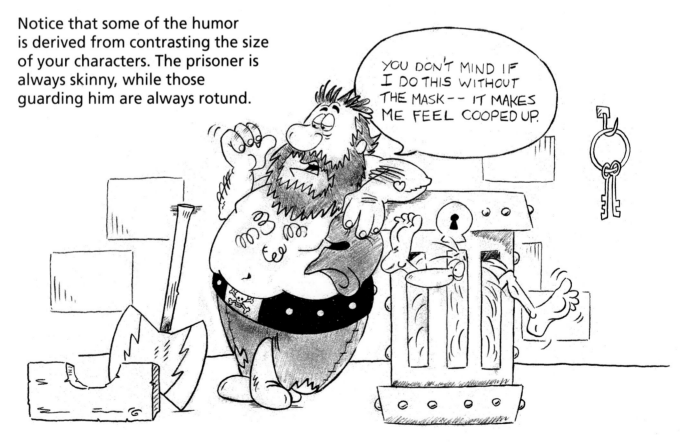

YOU DON'T MIND IF I DO THIS WITHOUT THE MASK -- IT MAKES ME FEEL COOPED UP.

Silhouettes

Silhouettes are used to break the monotony of a series of drawings or to depict nocturnal scenes.

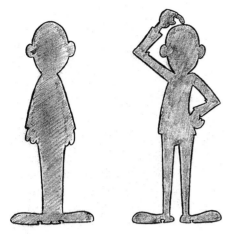

Silhouettes of people are most effective when the limbs hang away from the body, allowing negative space to fill the gaps.

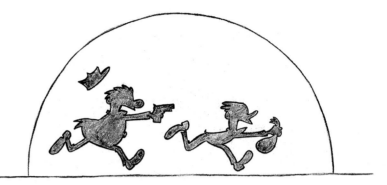

A silhouette against a giant sunset is always winning.

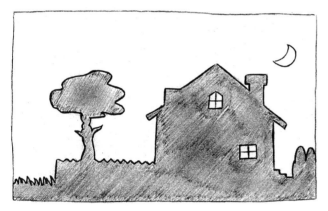

Look how sleepy this house appears, simply because it is drawn in silhouette.

NEGATIVE SILHOUETTES

This is a common variation. By keeping your characters apart, the silhouette remains clear.

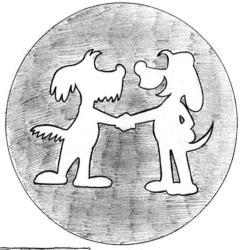

When two characters must overlap, one advantage of a negative silhouette is that you can "cheat" by drawing the overlapping line, as in the case of the gentleman's arm, which is patting his friend's shoulder.

SAMPLE LAYOUTS

Here are a few sample layouts that you can use as inspiration in developing your own scenes. Experiment by placing one, two, or more characters in a scene. If you can come up with a funny line, put it in a dialogue balloon emanating from your character, or in a caption underneath your drawing. If you can't think of anything funny, then try illustrating a joke you've heard, using several panels to tell the story. You will have just created your own comic strip.

Some cartoonists decide exactly what they want to draw before they even pick up a pencil. There are others who sketch away dreamily until they stumble upon something they think is good, and then build upon it. Don't think you have to work in one particular way. There is no "right" way to approach your cartooning. Try both methods, and go with what makes *you* comfortable.

You may be bursting with excitement and, because of your enthusiasm you may weigh your drawings down with so much stuff that your scene loses its humor and punch. Remember, in cartooning as in many other facets of life, brevity is the soul of wit.

It is also worth mentioning that you will advance faster if you experiment with different things rather than struggle to perfect each drawing you attempt. Relax. Have fun. This isn't the Sistine Chapel!

A Rose is a Rose, But a Tree...

WOODS, MOUNTAINS, NORTHERN COUNTRIES

Different types of trees connote different geography. It is important to match the objects in the background with the specific locale that you are trying to establish. A cactus reads as the West. The Eiffel Tower reads as Europe. A house with a shingled roof reads as a dwelling in the country or suburbs, but not in the city.

BACK YARD, FOREST, SHERWOOD FOREST

THE TROPICS, HOLLYWOOD, LAS VEGAS

Simple Home Interiors

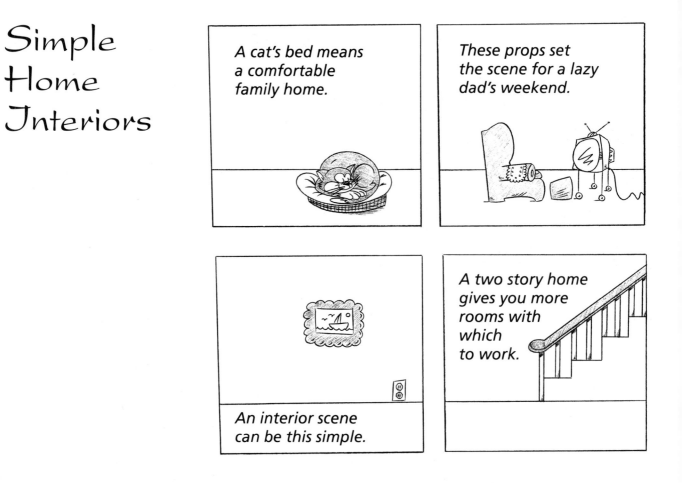

A cat's bed means a comfortable family home.

These props set the scene for a lazy dad's weekend.

An interior scene can be this simple.

A two story home gives you more rooms with which to work.

Although there is a mathematical formula to help you arrive at precisely where shadows should be cast (can you believe it?), it is unnecessary for our purposes. Just keep the shadows a respectable distance from the light sources, which in these drawings are a window and a light bulb. Long shadows bank off the floors and walls.

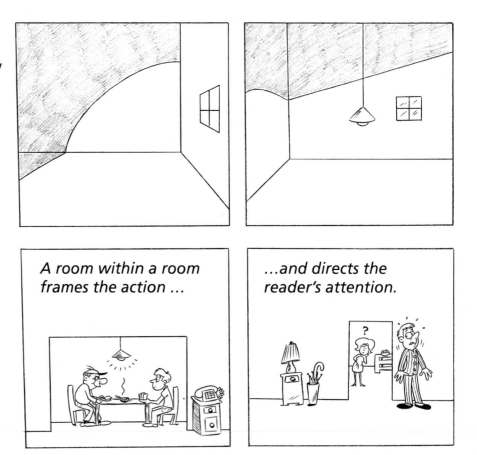

A room within a room frames the action ...

...and directs the reader's attention.

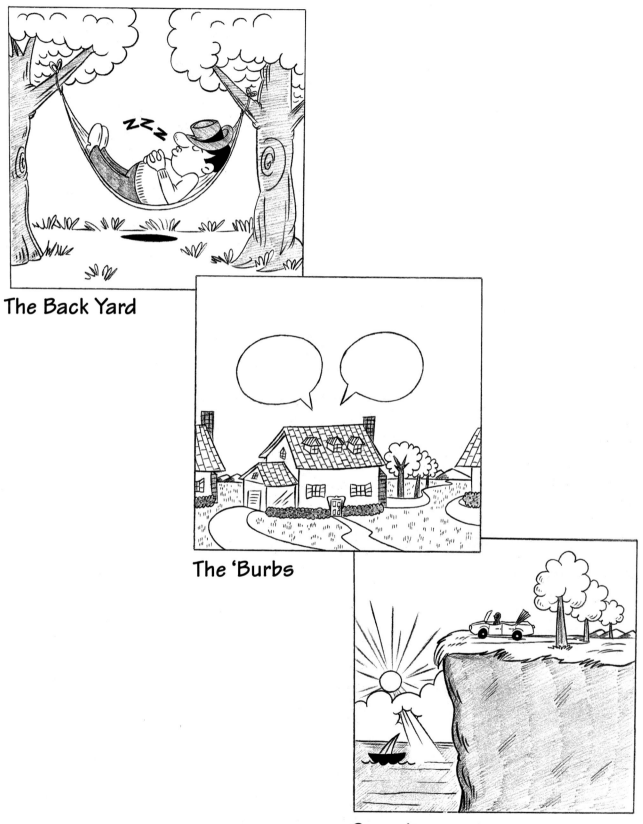

The Back Yard

The 'Burbs

Serenity

Layouts From a Distance

Make the dialogue balloons smooth and the clouds bumpy so that the reader will not confuse the two.

A private moment. In this layout, we, the readers, are relegated to the role of observers.

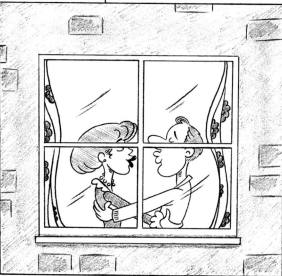

An island resort.

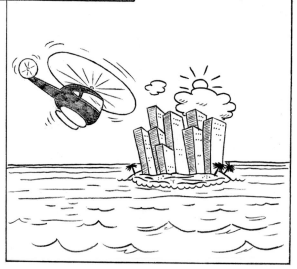

*Two characters in a scene
observe another scene.*

Spying through binoculars.

A tilted horizontal plane.

Overhead view of a room.

WEATHER CONDITIONS, LIGHT, AND DARK

Weather effects give an accent to cartoon illustration. Some of my earliest memories of illustrated childhood storybooks are of scenes of blustery days. But how do you draw wind?

Some of the funniest comic strips I recall are about poor souls stranded in the searing heat of the desert, searching for an oasis. How do you indicate searing heat?

In this chapter, I will reveal all that and more. You will discover that by using the effects of nature and light, your cartoon world becomes increasingly more real to the reader.

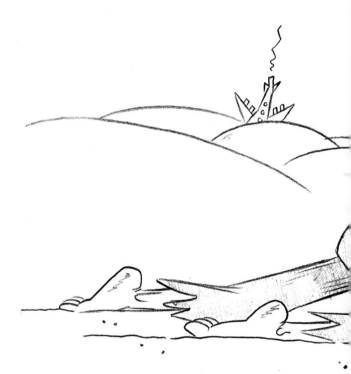

Searing Sun

Show sky, and plenty of it (draw the horizon line low on the page). Not a cloud is in sight. Remember, clouds are a portent of rain, and there isn't going to be any rain here. The sun is drawn as a ball with broken, curving lines around it. This type of sun is only used to indicate extreme heat. There are no mountains in the background, because that would cast shadows and shadows are cool.

Wind

Think of autumn. To underline an autumnal flavor, think of New England when costuming your character. Show the wind by drawing swirling lines. Leaves are blown. Clothing flaps. The wind causes the trees to sway backwards, while the man leans forward into the gust. Plenty of clouds in the sky indicate turbulent weather.

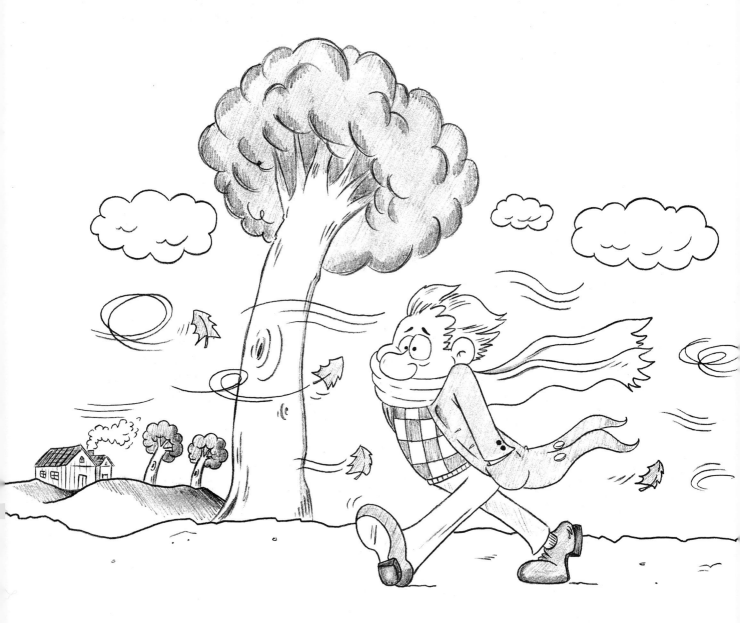

Let it Rain

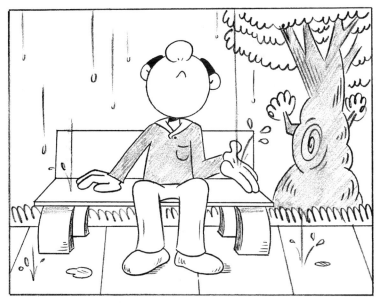

Rain is indicated by straight lines with droplets at the ends. If you prefer, you can draw straight lines without the droplets, but not the other way around. If you drew droplets without the straight lines, the droplets would read as tiny snow flakes. Puddles and bouncing rain lines are also helpful in setting the scene.

Drizzle

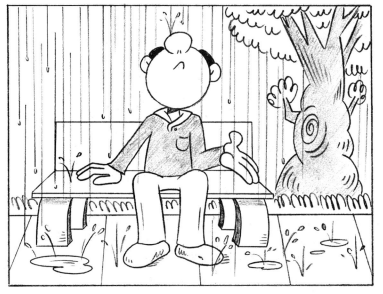

Hard rain
Now the picture becomes humorous, because the guy is feeling for rain with his hand while the rest of him is getting soaked.

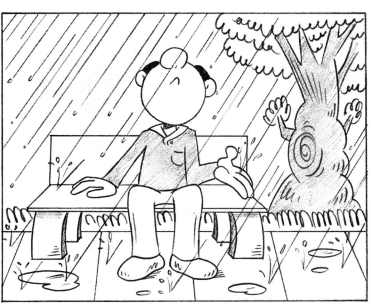

Hard rain at an angle

Winter Wonderlands

No sun should appear in winter scenes, because the sun indicates heat.

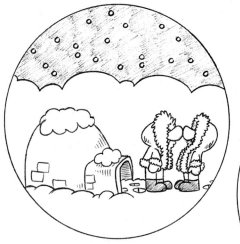

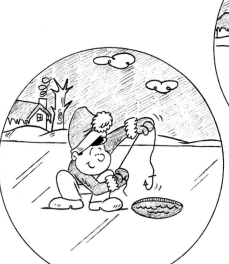

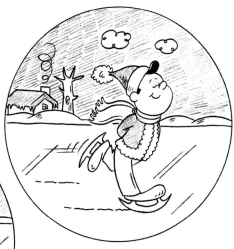

North Pole
Note that the snow only appears in the sky, not below the horizon line. Snow lands in clumps on top of the igloo.

Ice Fishing Hole
A popular cartoon standard. Ice-covered lakes read best if they are deep, taking up a large portion of the layout. Leave the ice clean for a slick look.

Ice Skating
The skates leave a groove in the ice. Notice that the house in the background has icicles hanging from its roof and that the tree is bare.

Cloud Formations

A black and white loosely lined sky gives the illusion of being deep blue.

Dust is indicated by broken clouds and specks of dirt through which we can see some of the floor line.

COUGH COUGH

Cityscape

A cityscape can present a dynamic combination of clouds, sky, light, and shadows.

Top to bottom clouds give a sprawling urban look.

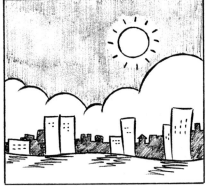

Low clouds indicate a tranquil atmosphere.

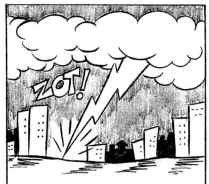

Threatening clouds loom over the city as thunder rumbles and lightning strikes.

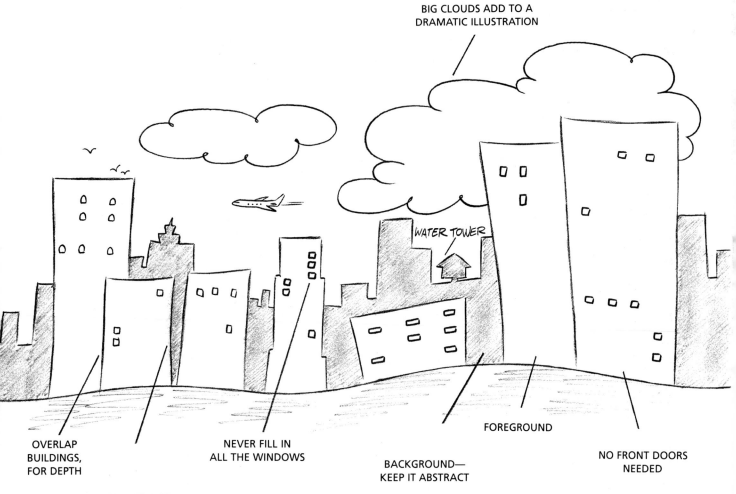

BIG CLOUDS ADD TO A DRAMATIC ILLUSTRATION

WATER TOWER

OVERLAP BUILDINGS, FOR DEPTH

BUILDINGS NEED NOT BE DRAWN RULER-STRAIGHT

NEVER FILL IN ALL THE WINDOWS

BACKGROUND— KEEP IT ABSTRACT

FOREGROUND

NO FRONT DOORS NEEDED

Me and My Shadow

The higher the sun appears in the sky, the smaller the shadow is.
The lower the sun is in the sky, the longer you must make the shadow.

Light and Dark

Light does not necessarily hit all objects evenly. This fellow's top half is all that receives the light from the street lamp.

Flames, and sometimes light bulbs, emit a star glow, indicated by a circle of broken lines.

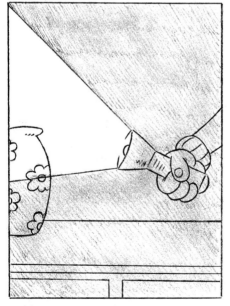

Flashlights abruptly slice the darkness in half. The effect is the same on objects in their path, such as this vase.

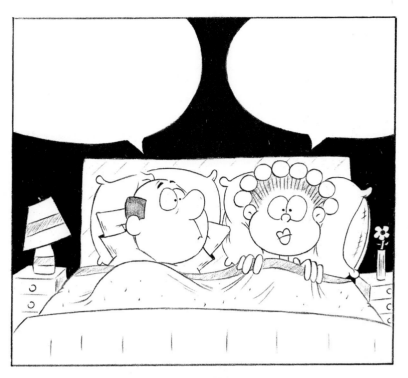

The walls can be blackened to indicate night, but we've conveniently left our couple, the bed, and the end tables illuminated, which is, of course, physically impossible. But hey, it's a cartoon. You can do anything you want. This technique allows you to draw a nighttime scene without sacrificing any visuals.

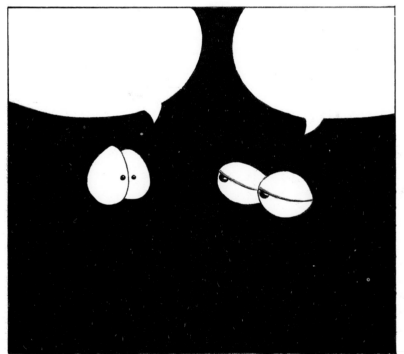

This scene places more emphasis on the nighttime quality. Notice that the eyes have gotten bigger, taking up more room in the panel. The eyes are also more stylized so the reader can tell who is who.

This alternative is highly stylized. We see only the dialogue balloons. Place one balloon higher, and one lower, to differentiate the characters.

WINDOWS, ICE, GLASSES, AND WATER

Every once in a while, you attempt to draw something that throws you a curve. And it just drives you CRAZY, because if it weren't for that one snag, you would have had your drawing finished hours ago.

This is the troubleshooting section of the book. I will present the standard manner in which tricky visual situations are handled by professional cartoonists, so that you won't have to reinvent the wheel. In addition, you will find that these special techniques add interesting accents to your drawings.

For example, windows, ice, glasses, and water need special treatment. They are translucent, which is a fancy way of saying that light shines through them. Perhaps you believe that you don't need to indicate the glass in a glass window, because it appears to be invisible to you. The problem with that notion is that the window might appear to the reader to be opened when, in fact, you meant it to be closed. One solution is to draw the windows with window panes. However, if you're drawing a scene in the office of an executive, the windows of the office wouldn't have window panes, so you're back where you started. The illustrations in this chapter will show you how cartoonists solve this and many other challenges.

A window in front of a silhouetted figure does not need reflection lines.

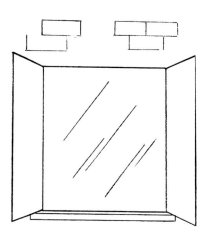

With a closed window, reflection is indicated by repeated diagonal lines.

Half-open windows are scene stealers. Lose the interior background.

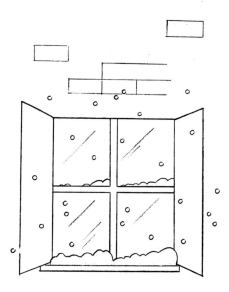

Window panes are a nice touch, especially for winter scenes, as they allow the snow to accumulate.

Don't be afraid to draw reflection lines over a Character's face.

We are now inside a house, looking out at the neighborhood. Nighttime window scenes always include a crescent moon.

An ice pond is a mirror turned on its side.

Even though they are square shapes, ice cubes have squiggly lines.

To create a mirror image, flip your drawing over and trace the reverse side onto the mirror. Dialogue balloons don't have any reflection. They are "invisible."

Glasses

Glasses are a wonderful detail that can add character.

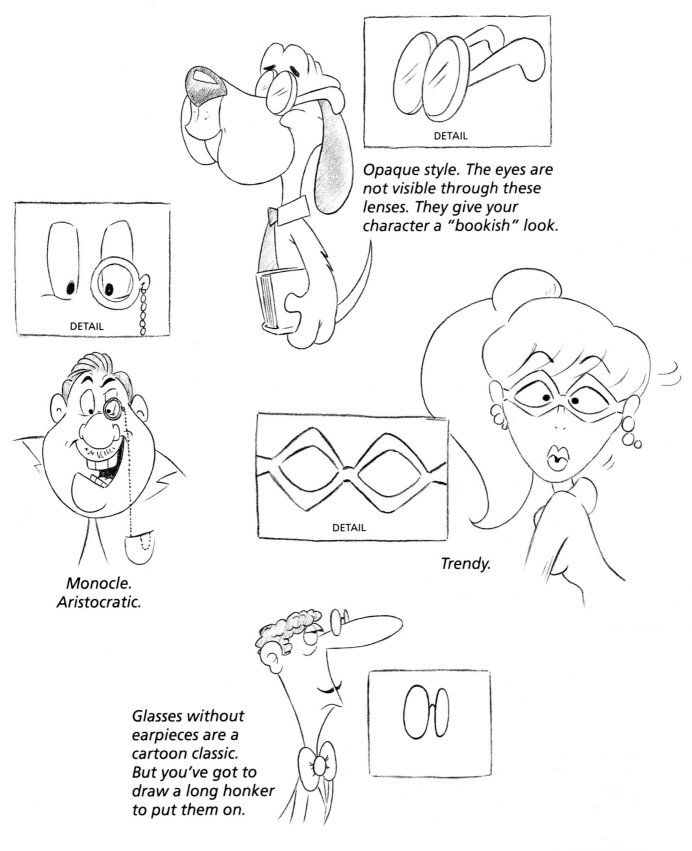

DETAIL

Opaque style. The eyes are not visible through these lenses. They give your character a "bookish" look.

DETAIL

DETAIL

Trendy.

Monocle. Aristocratic.

Glasses without earpieces are a cartoon classic. But you've got to draw a long honker to put them on.

The Deep Blue Sea

The world may not be flat, but cartoon oceans often are. This stylized technique is found primarily in children's books and in limited animation.

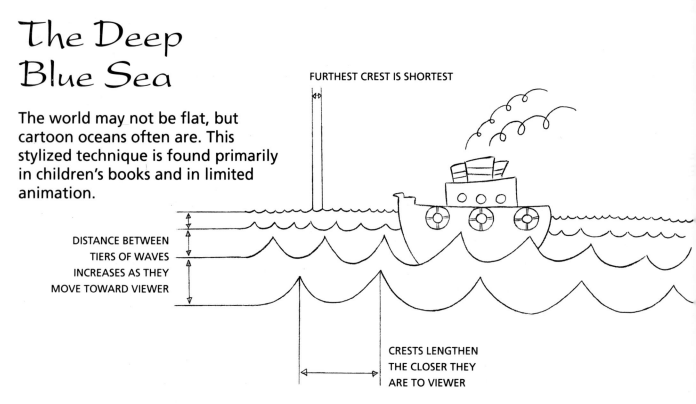

FURTHEST CREST IS SHORTEST

DISTANCE BETWEEN TIERS OF WAVES INCREASES AS THEY MOVE TOWARD VIEWER

CRESTS LENGTHEN THE CLOSER THEY ARE TO VIEWER

A more natural version of the ocean can be attained by softening the peaks of the waves, and breaking the waves up into sections of one or two so that they don't run the length of the sea on a single line. You can add white caps, as well.

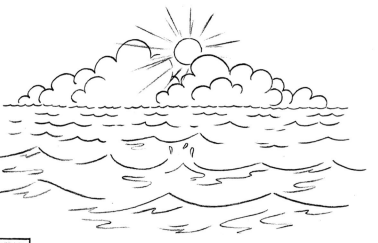

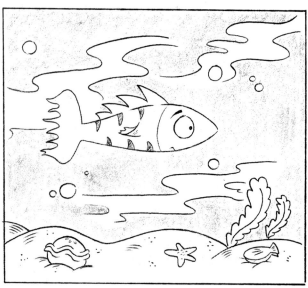

Underwater scenes are indicated by currents. Think of currents as ribbons that flow horizontally, drift apart, and then come back together again. Add bubbles and some sea flora.

Splish-Splash, I Was Takin' a Bath

Calm waters

Ripples expand as they drift away from the center.

Whoa! The water erupts as the guy dives in. The waves become choppy, and water sprays into the air.

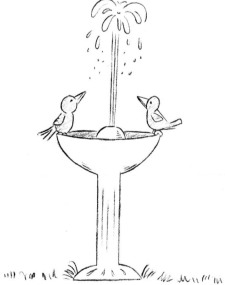

Fountains have flower petal-like tops, and droplets that sprinkle down.

THE SPECIAL EFFECTS LAB

Special effects give professional cartoonists an edge. Maybe that's why there has been so little written about this subject. At the risk of telling a secret of the profession, and being kicked out of the official Cartoonists' Fraternity as a punishment, I am laying out the information in black and white for everyone to see.

After you've finished this chapter, you'll know how to illustrate movement, speed, force, and impact. You'll be able to show your characters in a fight that looks real, and illustrate explosions that your readers can almost hear. In fact, you'll be able to make your cartoons seem to leap right off the page.

I must be touching a sensitive nerve. I've already received threats warning me not to proceed. I've gotten letters telling me that if I dare to divulge cartoonists' carefully guarded secrets, I will be the "random" victim of a heaved banana cream pie, or a safe may fall on my head as I'm walking down the street. Or, perhaps a mouse will invade my home and terrorize my cat. Or something equally terrible may happen.

But a free press must never be censored. Therefore, I move into uncharted waters as I bring you the secrets of the Special Effects Lab...

No matter how well you draw this pose, the ball will still look as though it's floating in midair. And although the kid is certainly leaning into the throw, he looks like a statue, frozen in time.

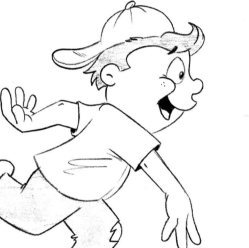

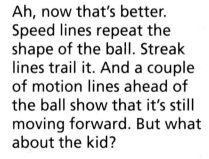

Ah, now that's better. Speed lines repeat the shape of the ball. Streak lines trail it. And a couple of motion lines ahead of the ball show that it's still moving forward. But what about the kid?

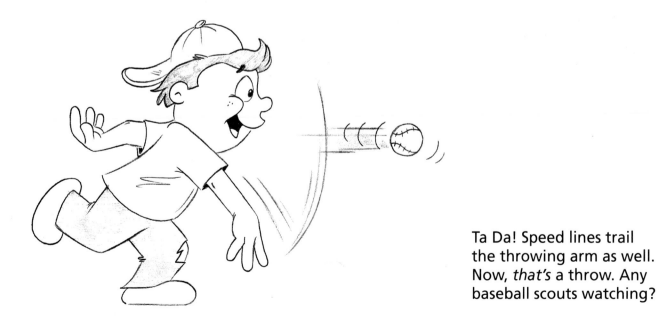

Ta Da! Speed lines trail the throwing arm as well. Now, *that's* a throw. Any baseball scouts watching?

Impact Stars and Vibration Lines

Impact stars are inexact stars, with the ends left open. Because of the severity of the impact, the vibration lines must be more than a few repeated lines around a face. If you look closely, you will see that there are five different eyes drawn, as well as five noses, three mouths, and two ears.

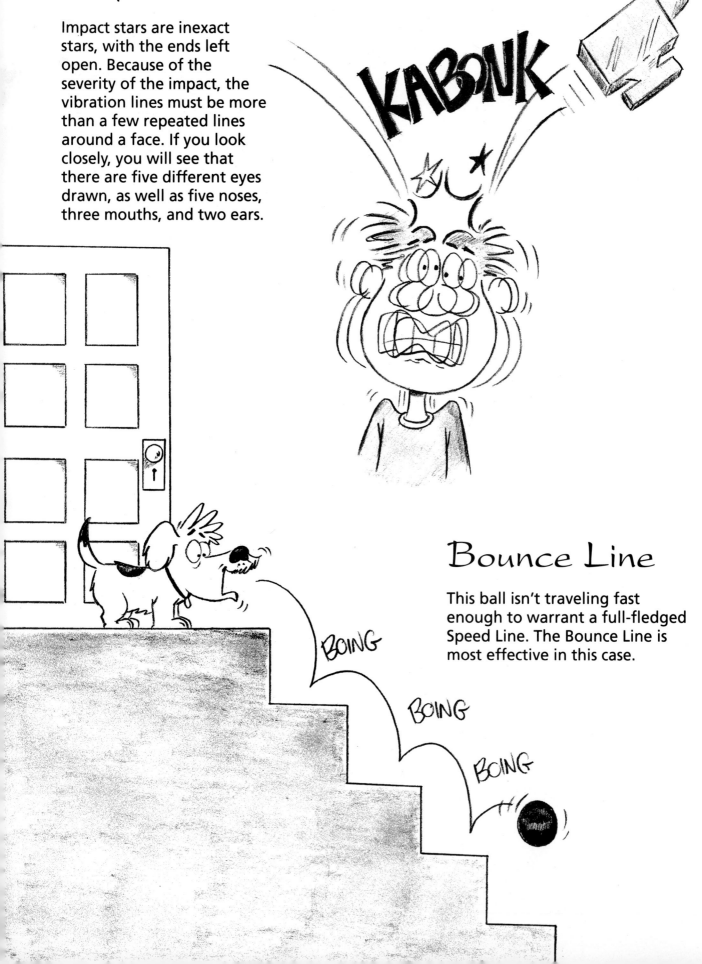

Bounce Line

This ball isn't traveling fast enough to warrant a full-fledged Speed Line. The Bounce Line is most effective in this case.

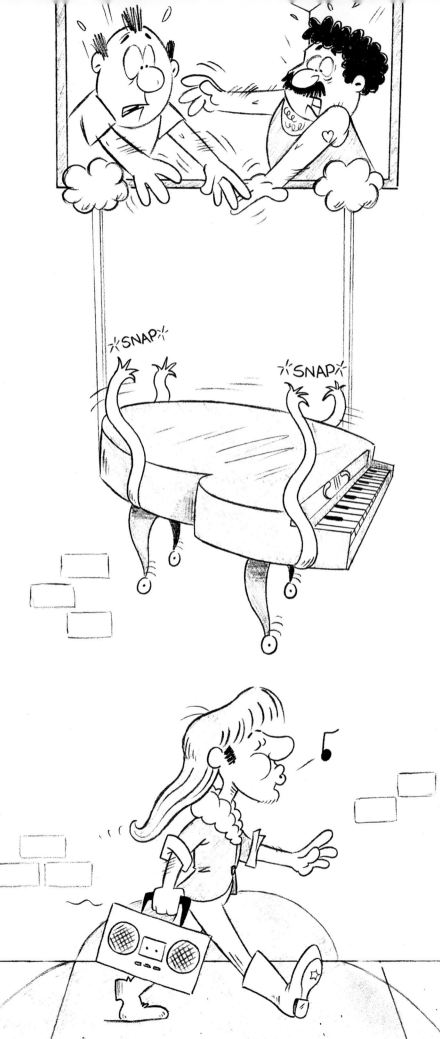

Fast Speed Lines

Fast traveling objects, like this falling piano, require speed lines that are ruler-straight. They also have clouds of smoke at their origin. Man, this one's gonna hurt.

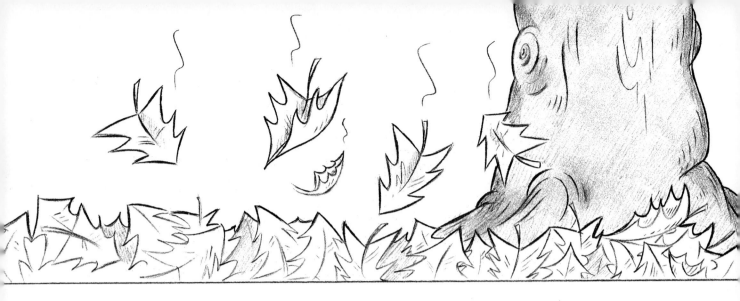

Lyrical Speed Lines convey an innocent attitude as much as they do an action. Use them for falling leaves, butterflies, a happy walk, etc.

Cars, bikes, motorcycles, sleds, and skateboards literally leap off the ground when traveling fast. Distort the object so that it leans aggressively into the action. Only a few Speed Lines are necessary for these scenes.

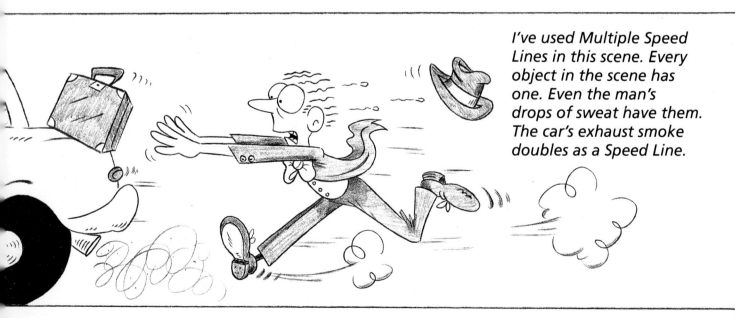

I've used Multiple Speed Lines in this scene. Every object in the scene has one. Even the man's drops of sweat have them. The car's exhaust smoke doubles as a Speed Line.

Explosions

Get out of the way! Wow, I can really feel that explosion. What gives it such a dynamic look? You may be surprised by the answer. Even though we generally think of explosions as chaotic events, they are drawn in a very orderly manner. Keep your explosion neat and clean, and it will read as more powerful.

BLAM

Fight Cloud

A cartoon fight is portrayed in a very broad manner in order to take it out of the realm of reality so that we can be entertained by it. The best way to do this is to use what is called a "Fight Cloud." Although a Fight Cloud gives the appearance of a rough and tumble fight, we don't get to see anyone getting hurt. It is all masked behind a cloud. However, lest anyone think that the combatants are just playing in there, dentures and glasses usually come flying out, amidst glimpses of tugging limbs.

Letter Writing

To show what a character is writing as he composes a letter, position the printing over his head without a dialogue balloon. The style of lettering must reflect the character and the period in which he lives.

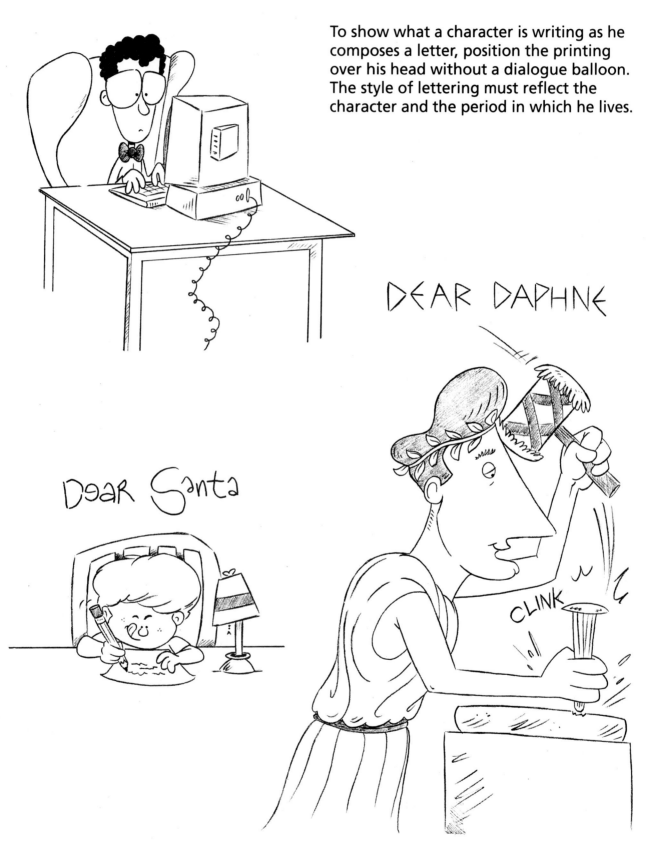

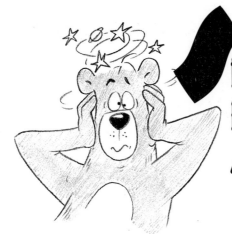

SPECIAL EFFECTS FOR EXPRESSIONS AND POSES

Let me just wipe some of that banana cream pie from my new suit jacket. There. That doesn't look so bad, does it? Yes, I was accosted by an angry mob of cartoonists for revealing the secrets of special effects in the last chapter, but just the same, I'm at it again.

In this chapter, we'll uncover the secrets of Special Effects for Expressions and Poses. No matter what expression or pose you draw for your character, adding these special effects will double the cartoon's effect on the reader. Many of these poses give an extra punch to a punchline.

Once you have mastered basic expressions, such as "happy," "sad," "tired," etc., you will want to move on to the more advanced and zany expressions found in this chapter.

By using special effects to enhance your characters' expressions, the characters will become that much more cartoony. After all, when you or I get an idea, a light bulb doesn't appear over our heads. Today's cartoons exhibit wild, over-the-top expressions, such as the cartoon "take" in which a character violently recoils from something, as a mouse would from seeing a cat. This, too, is a form of special effects.

To show what a character is thinking, you could draw a thought balloon with the appropriate words instead of using special effects. However, cartooning is a visual medium; therefore, the rule of thumb is: Show it, don't tell it. If you can show something by using a drawing, rather than by using words, it's all the better.

Let's Start with a Pliable Character

3/4 VIEW—LEFT

3/4 VIEW—RIGHT

PROFILE—RIGHT

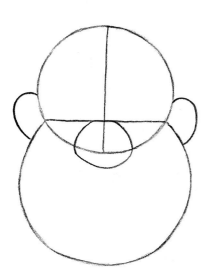

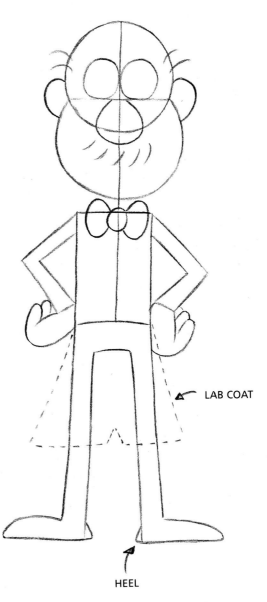

LAB COAT

HEEL

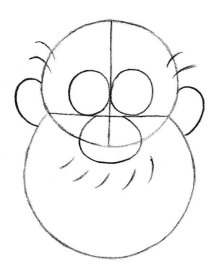

Body built on a simple rectangle.

Halo

Character looks at his own halo in either sincere or feigned innocence.

Beating Heart

An extreme "in love" pose.

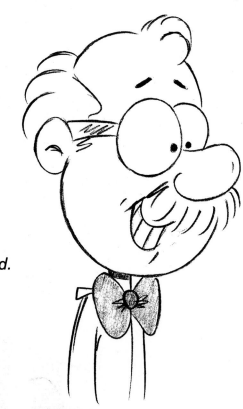

Light Bulb

An idea is hatched.

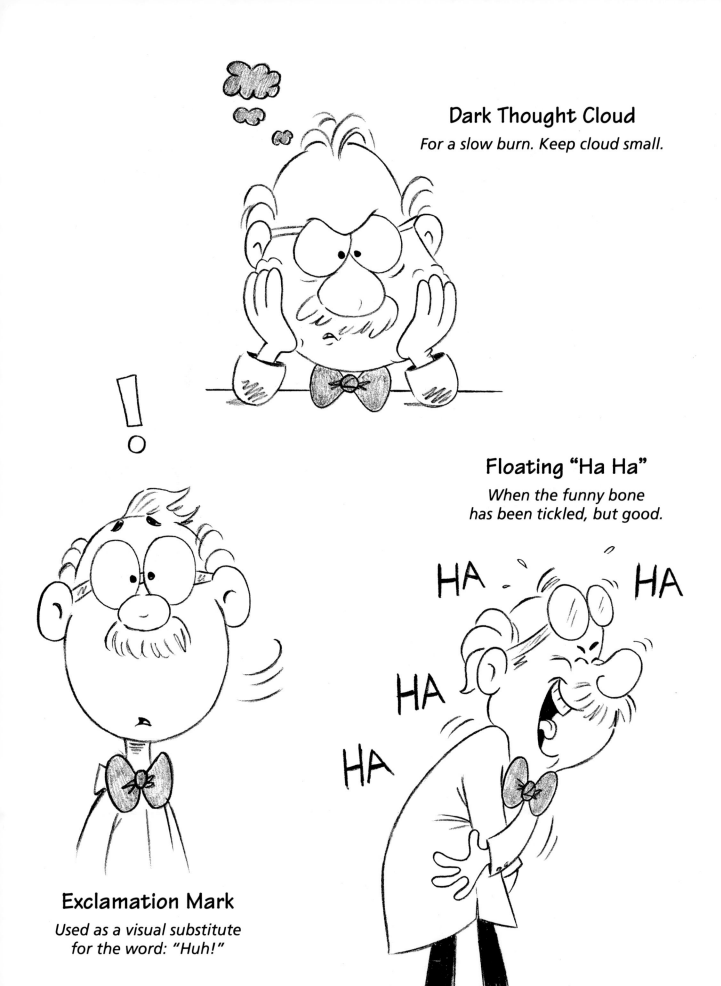

Dark Thought Cloud
For a slow burn. Keep cloud small.

Floating "Ha Ha"
When the funny bone has been tickled, but good.

Exclamation Mark
Used as a visual substitute for the word: "Huh!"

Special Effects for Animals

Let's try some special effects on the animal kingdom. To do this, we must first find a character versatile enough to display extreme exressions without losing its basic nature. For this purpose, I have chosen the brown bear. He is an affable member of the cartoon animal kingdom, and his simple, basic structure is easy to master. I've provided a construction chart of the brown bear for you to practice on. Familiarize yourself with the character before adding the effects.

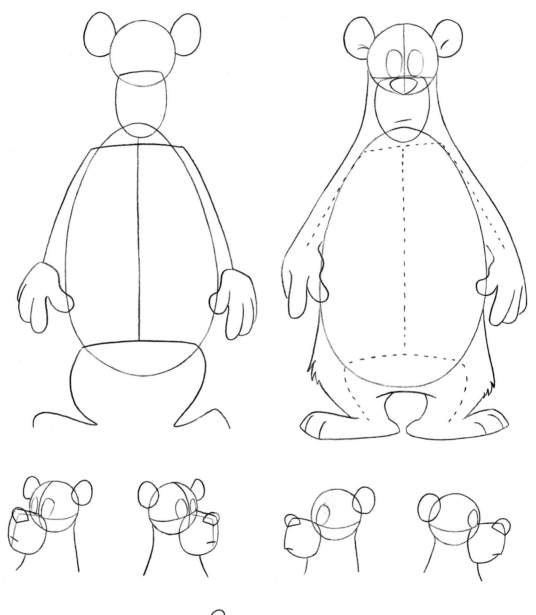

Puzzle Star

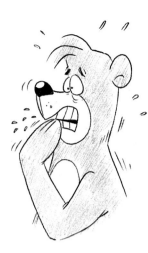

Nail Bites

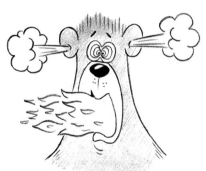

Hurt Stars

Surprise Lines

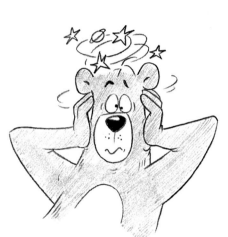

Dizzy Stars and Planets

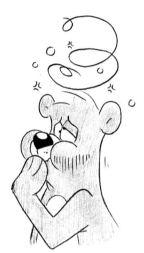

Sickening Swirls

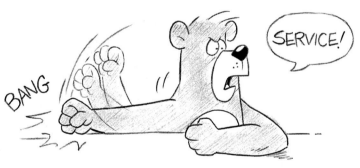

BANG

SERVICE!

Animation

The trailing images of the "hands" are drawn lighter.

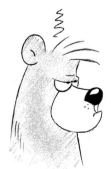

Brooding Squiggle Line

Hot Tamale

Several effects are at work here at the same time: swirling eyes, hair standing up straight, smoke coming out of the ears, and fire coming out of the mouth.

"Takes"

A take is the most extreme expression there is, period. It is often hysterically funny. The head and features are so exaggerated that special attention must be paid not to destroy the original integrity of the character.

EYE SOCKET TAKE

The eye furthest from the reader must be the longest for this pose to work. The eye socket take works best in profile and 3/4 view poses. Remember to throw in a couple of pumped up blood vessels for good measure. The mouth is opened so wide that we even see the uvula way in the back. Sweat lines, surprise lines, they're all at work here!

The Classic Eye-Pop Take

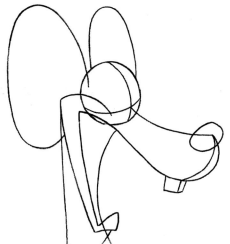

NORMAL EYES

BULGING EYES

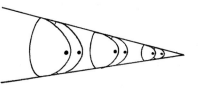

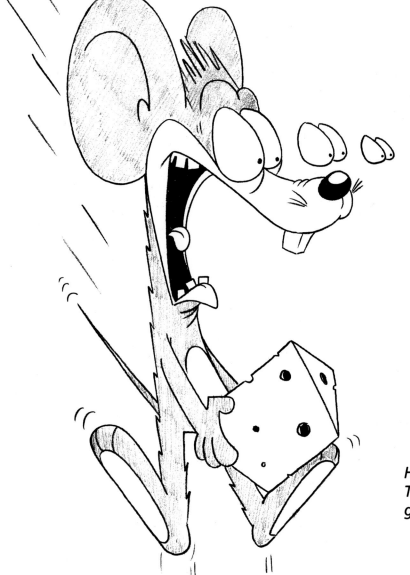

*Holy smokes!
The whole body
goes into the take.*

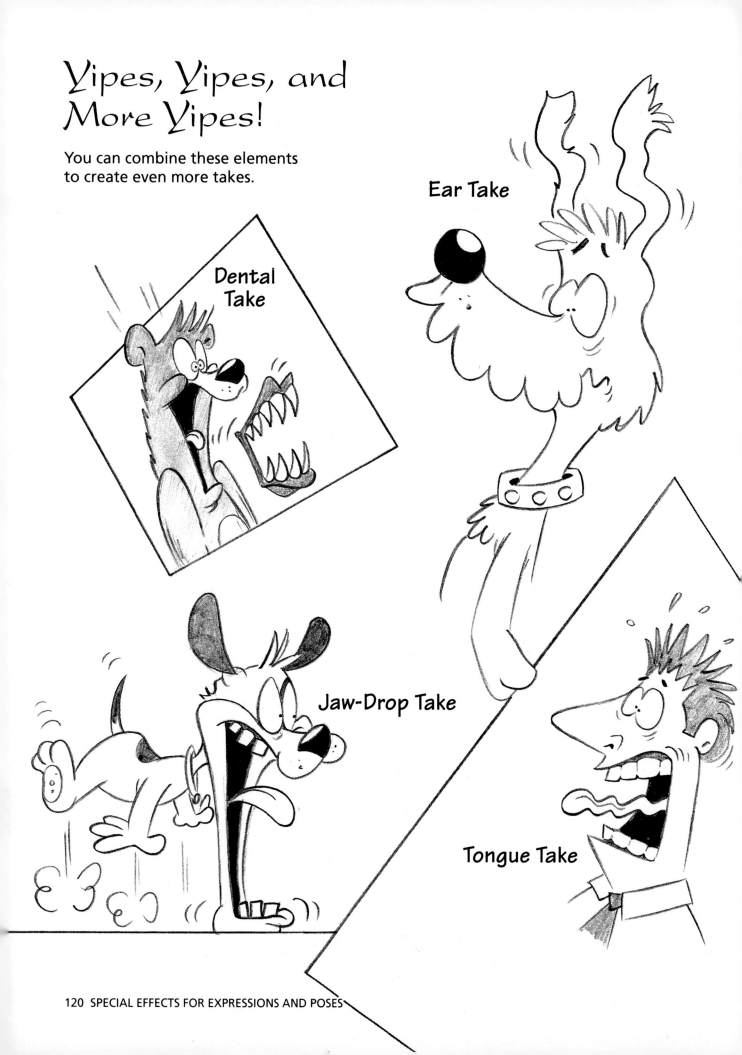

Yipes, Yipes, and More Yipes!

You can combine these elements to create even more takes.

Ear Take

Dental Take

Jaw-Drop Take

Tongue Take

The Classic Double-Take

This is an advanced construction. It requires drawing five faces on one head. But it's an all-time favorite.

Sketch the first face, in a front view.

Next, add two more faces at 3/4 angles, one left and one right.

Add two profiles, one left and one right.

CARTOON SOUND EFFECTS

Whoever said that actions speak louder than words didn't know a lot about cartooning. Watch, I'll probably find out that Socrates said it. Okay, maybe Socrates was a great thinker, I'll give him that much, but his stick figures were really the pits.

In cartoons, the *impact* that is made when one object collides with another is muted unless there is a bold sound effect that goes with it. In the same fashion, some softer, subtler expressions lose their charm unless the image is accompanied by subtle sound effects.

Sound effects that go along with a cartoon can crystallize a thought for the reader. In fact, over the years they have proven to be so effective, and have been so widely used, that the average reader has grown to *expect* them.

So how do you draw a washing machine that is on, as opposed to one that is just standing there, *off*? You use a sound effect that describes a noisy washing action.

The world is filled with sights and sounds. Let's start using them...

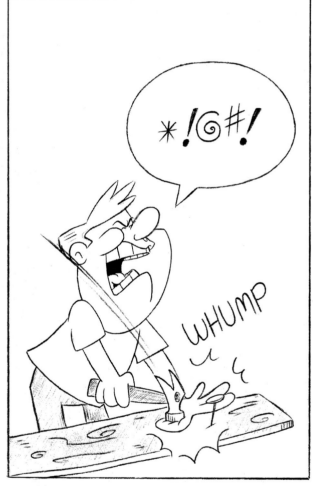

EXCLAMATORY REMARKS

Foul language is strictly a no-no. Some creative punctuation is funnier and keeps it clean.

Repeated Sound Effects

Repeated sounds become the background. (Note that in this illustration the vibration lines exactly mirror the contours of the body.)

RAT-TAT-TAT
RAT-TAT-TAT
RAT-TAT-TAT
TAT-TAT
AT-TAT

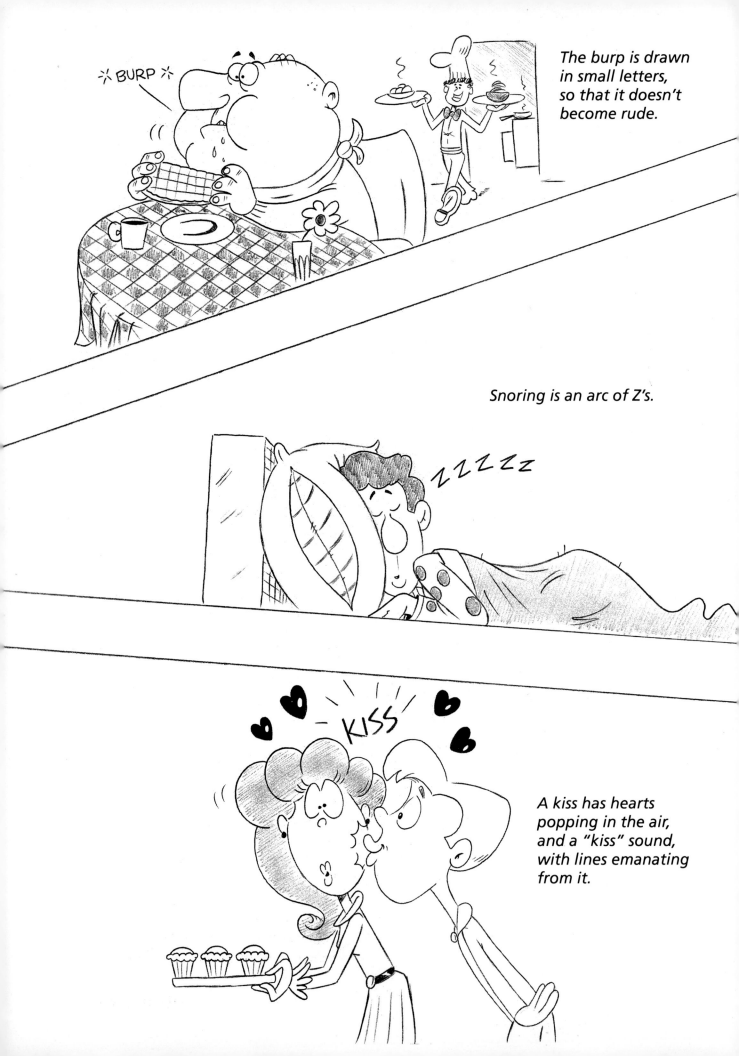

The burp is drawn in small letters, so that it doesn't become rude.

Snoring is an arc of Z's.

A kiss has hearts popping in the air, and a "kiss" sound, with lines emanating from it.

The style of the lettering of a sound effect, or the framing around that lettering, can echo the action it is describing. In this example, the lettering and the balloon it is in both resemble a splattering pie.

Understated lettering, like this "tap tap," can actually add emphasis to a scene. This looks like the hand of the IRS coming to greet our hero.

Bells and ringing sounds have jumbled letters.

Any action that has no stereotypical sound effect associated with it, such as a washing machine working, takes the *verb* as its sound effect.

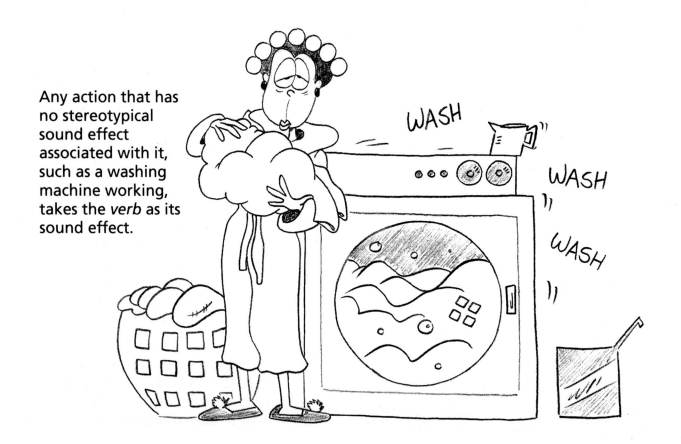

Sob City

Tears come in all varieties to illustrate different levels of emotion, from little tears to all-out wailing. Here are some variations:

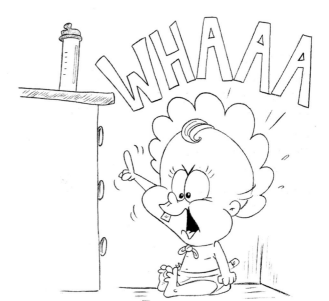

Anguished tears stream forth like fountains. The word "aaugh" denotes an adult's cry.

Sniff Sniff

"Sob sob" works equally well.

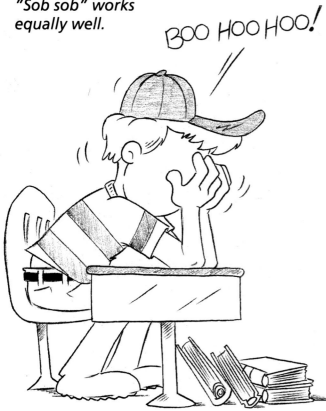

BOO HOO HOO!

WHAAA

This little baby knows who's the boss. The huge letters form an arc over her head. The word "whaaa" denotes a baby's cry.

CHOOSING COLOR/ SAMPLES OF FINISHED CARTOONS

As my grandfather used to say, "Now you're cooking with gas!" He was brought up in the days when a gas stove was a big deal. I'm sure he never imagined the days when people would routinely "nuke" their food.

Cooking with gas is something that everybody now takes for granted. But vibrant, eye catching colors continue to please readers and audiences all over the world. That's why the Sunday funnies are so special. That's why black and white movies are now extinct. Everyone loves color.

You are no longer a beginner in the world of cartooning. Therefore, I urge you to move past thinking about color as merely "filling in" the insides of a cartoon. Colors have

definite effects on our emotions and perceptions. We use colors to convey messages. Color is not something we do *after the fact*, it is an integral step in *the creation of the character*.

There are many guidelines in using colors, but few rules. Nothing is etched in stone. Much depends upon personal taste. One person may wear a green outfit, and it will look good on him. But when somebody else wears it, people giggle as he enters the room. This is why I've stopped wearing green.

There are many different mediums that are available to you: markers, colored pencils, pastels, and paints. Any art store will be more than glad to acquaint you with all of the popular mediums.

"Blue wash" is a term used to describe a blue tone that envelopes a scene. The color of night is blue. Blue is a cool color, unlike red, which is a hot color. Therefore, you can feel the quiet and solitude of nighttime that is heightened by the blue wash. Using blue wash, we give the entire scene a tone with one stroke, eliminating the need to choose separate colors for all of the individual elements.

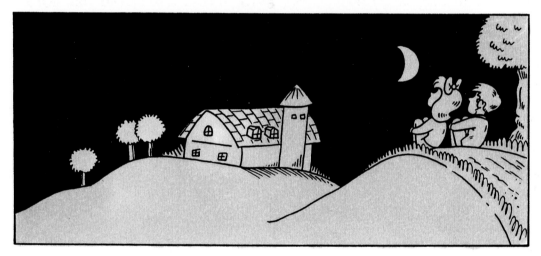

Color Recognition

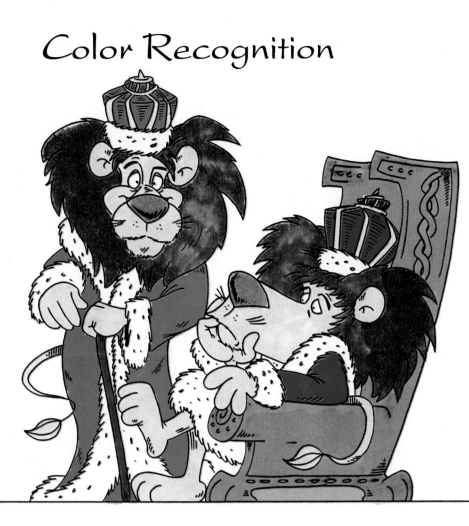

We immediately associate certain colors with specific functions. For instance, a king's robe is red. However, many times the immediate association you make will not be the only one, but merely the *first* one that springs to mind. To give yourself a wider palate from which to choose, dig for alternatives. In this example, royal blue is just as impressive on the king of the jungle.

This is an example of children's storybook style illustration, as indicated by the detail of the lines and the fact that the lion retains much of his animal-like appearance, even though he has taken on human posture.

I don't know about you, but I can't tell a boy mouse from a girl mouse. To help the reader draw a quick distinction between the sexes, we must assign each mouse a different color. Girls get pink or purple. Boys get blue or brown.

Colors that enhance a scene of courtship are: pink, red, and purple.

Coloring Letters, Animals, and Props

Letters pop off the page if they are in bright, vivid colors. The bear's growl is colored red because red conveys a hot emotion, such as anger, while the munching sound the beaver makes is colored yellow because yellow is a hyper color, connoting a sense of energy. Think of the sun.

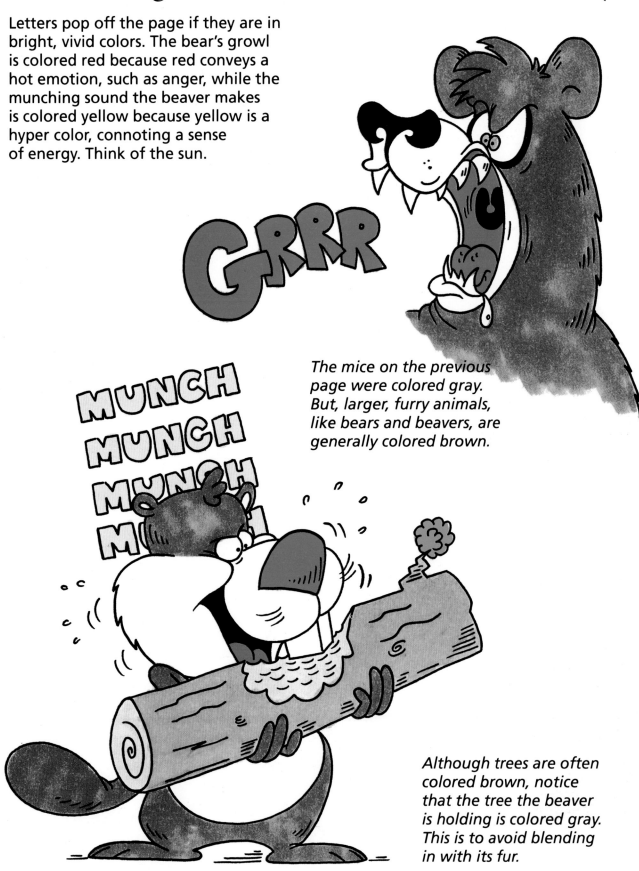

The mice on the previous page were colored gray. But, larger, furry animals, like bears and beavers, are generally colored brown.

Although trees are often colored brown, notice that the tree the beaver is holding is colored gray. This is to avoid blending in with its fur.

Faces

There are many varieties of flesh colors. You can buy the selections offered at your art store, or you can mix your own colors with paints, pastels, colored pencils or on the computer. Markers are harder to mix but there are a wide variety of hues available.

In choosing the correct flesh tone for your character be careful to avoid two extremes. Don't color your character with such a pale flesh tone that the color all but disappears when it is reproduced and, conversely, don't color your character with such dark flesh tones that the features are hard to make out.

The colors from which various flesh tones are usually mixed are: white, red, yellow, and brown.

Peach

Pinkish

Tan, Sandy

Brown

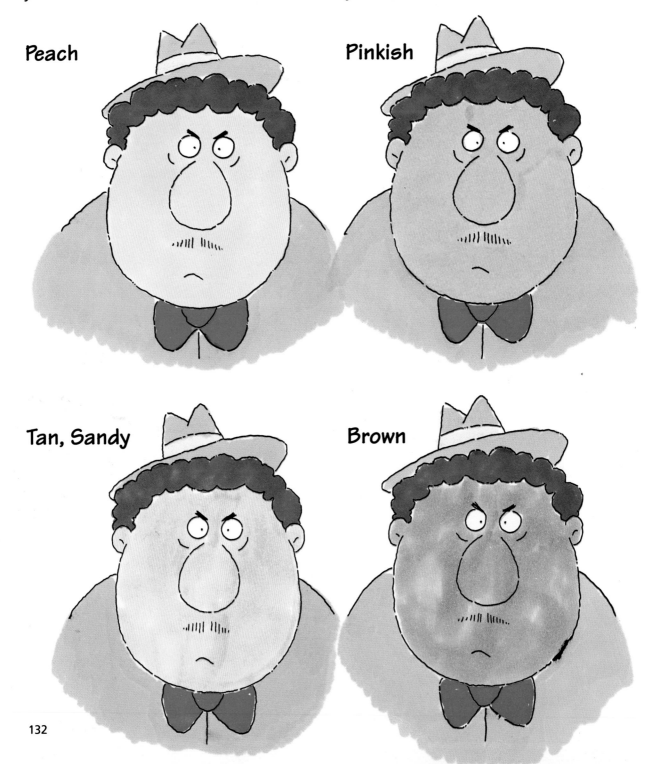

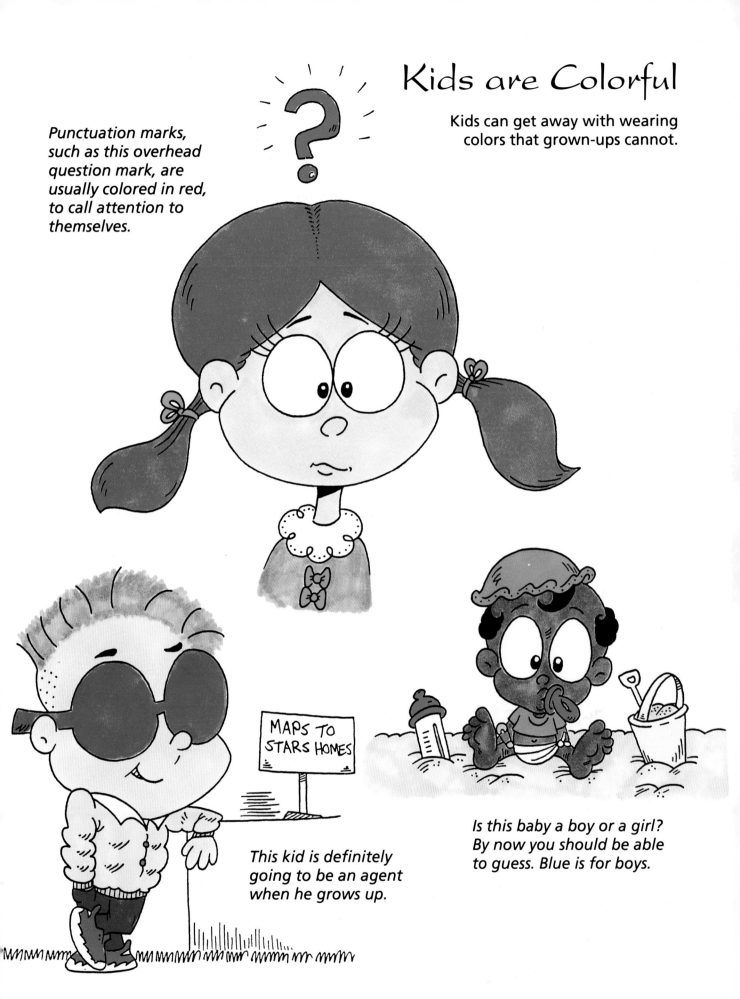

Kids are Colorful

Kids can get away with wearing colors that grown-ups cannot.

Punctuation marks, such as this overhead question mark, are usually colored in red, to call attention to themselves.

MAPS TO STARS HOMES

This kid is definitely going to be an agent when he grows up.

Is this baby a boy or a girl? By now you should be able to guess. Blue is for boys.

Hair Colors

Green is for weirdos.

*Blond is
a natural
for teenagers.*

*Redheads usually read
better if their hair
is colored orange.*

*Red, bushy beards
work especially well
on country folk.*

Color My Mood...

Colors can convey an emotional or a physical state...

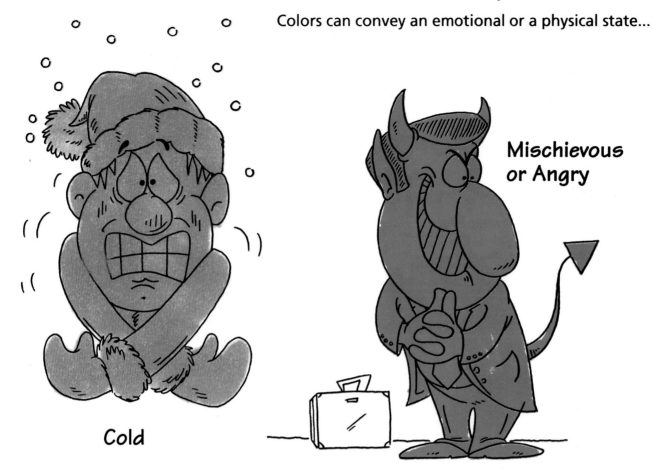

Cold

Mischievous or Angry

Envious or Nauseous

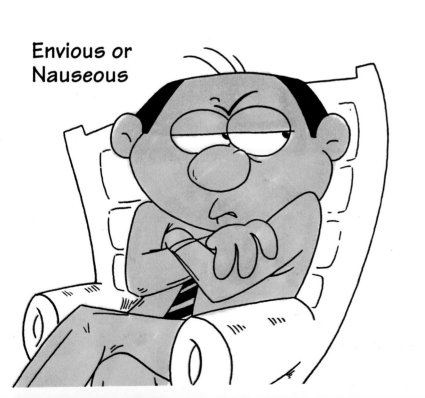

Fearful

Funny Color

Irony is a great tool in creating humor. Whereas in real life, a heavy-set lady might be inclined to wear stripes or black to camouflage her size, when drawing a cartoon we want to highlight our character's weaknesses. Bright colors are always funnier than darker colors.

Repetition and Humor

By repeating the same color scheme three times, we have achieved the desired humor in the scene. By coloring all of the characters identically, our eye is immediately drawn to the one thing that is different about them: their height. Had they each been wearing different colors, it would have taken the eye several more beats to get the joke.

The Sky

Is the sky blue? Well, sure, if you want to get technical about it. But in a cartoon we are not being literal, we are trying to create an image. A prehistoric sky can be pink, because of what it brings to mind: volcanoes and a savage earth. A sky can also be red or yellow, but never green, as green always reads as grass.

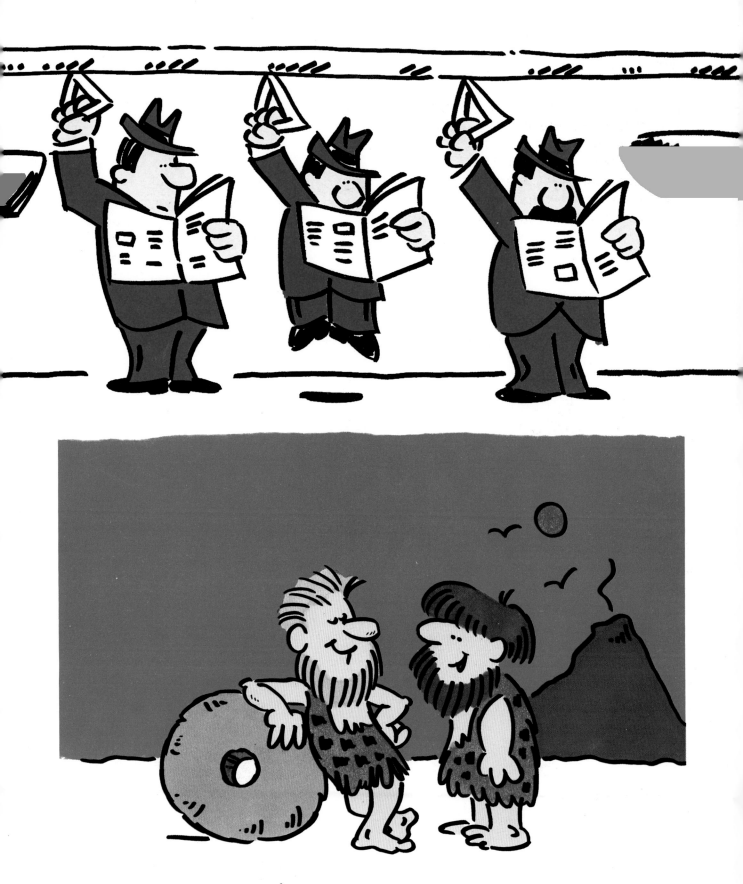

Decorating a Scene

Sometimes colorful props provide the fun in a cartoon.

Color Tests

Professional cartoonists make tests with different color combinations before settling on a color scheme.

Fantastic Creatures Take Fantastic Colors

Have you ever seen a purple horse? I haven't, either. But perhaps you have *in your dreams*. Fantasies are part of the dream landscape. They take on the colors of nighttime, which are colors with a good deal of blue in them, like purple and magenta. You can use any color for your fantasy creatures, but the further away from the blue spectrum you move, the less dream-like the fantasy appears and the wilder and wierder your creatures become, like the green space alien on this page.

When coloring fantasy creatures, be bold. You have created an illustration that is from the world of the imagination, therefore, don't color it realistically, or you will be at cross purposes. Follow your character's lead. Dream up unlikely color combinations.

Purple, blue, magenta, violet, lilac, lavender, green, and pink are the colors of fantasy.

Background Patches of Color

When working with color, you do not necessarily need to draw every background. An abstract color patch or design may serve just as well. This is generally used as a rhythmic break in a series of cartoons, such as in a comic strip, or to convey a strong emotion, or to focus extra attention on a character.

Use only bold, bright colors for backgrounds such as these, and be sure that your character's color is not similar.

HORIZONS: LOOKING TO TOMORROW...

We've come a long way together. I'm honored to have been, in some small way, a part of your progress.

If you've plugged away through most of this material, you've seen your drawing skill increase dramatically. If there are some sections that you haven't tackled yet, there's no need to rush. This book isn't going anywhere. It's your reference guide whenever you need it.

You may wish to pursue cartooning for pleasure, or you may be entertaining the possibilities of a career in the field. There are several areas in which you can specialize as a cartoonist.

ANIMATION

Animation is enjoying a second golden era. Not since the 1940s have animated motion pictures been so popular. And on television, animation is bigger than ever, and growing.

Animation is a tedious medium, requiring between 12 and 24 drawings to create one second of screen time. Animators love the exacting work. If you love animation, but can't see yourself as an animator, consider the following alternatives. There are storyboard artists, who create the camera shots; layout artists, who create the look of the scenes; and background artists, as well as writers, directors, and producers.

The rapidly expanding world of computer animation has added new dimensions to the field and is definitely worth exploring.

COMIC STRIPS

The comic strip is a favorite medium of the cartoonist, primarily because it affords the cartoonist the opportunity to establish his or her own characters. If the comic strip becomes successful, the characters enjoy a long life in the funny pages, and perhaps even go on to become successfully marketed in greeting cards and toys, and on film and television.

Unlike the animated film, the comic strip is not created by a committee. It is generally created by one cartoonist, although sometimes the work is divided among three people: a writer, who writes the jokes and suggests the layout; a cartoonist, who draws the characters and the backgrounds; and an inker, who inks and letters the final strip.

SPOT GAGS AND MORE

A spot gag is a one-panel cartoon with a punch line that generally appears in a magazine. The magazine that comes to mind most often when thinking of spot gags is *The New Yorker*. Spot gags are the best medium for conveying sophisticated humor. Political cartoons are a form of spot gags. Perhaps the idea of drawing one character over and over again, as in a comic strip or animation, doesn't appeal to you. You might consider spot gags.

There is also the world of advertising, which requires the work of talented cartoonists, designers, and illustrators. Of course, in the publishing field, no children's storybook would be complete without pictures.

Cartooning is a love affair with the wit, charm, and exuberance of your characters. If your adventures in cartooning give you even a fraction of the joy that I have had in creating this book for you, I will be very gratified.

INDEX